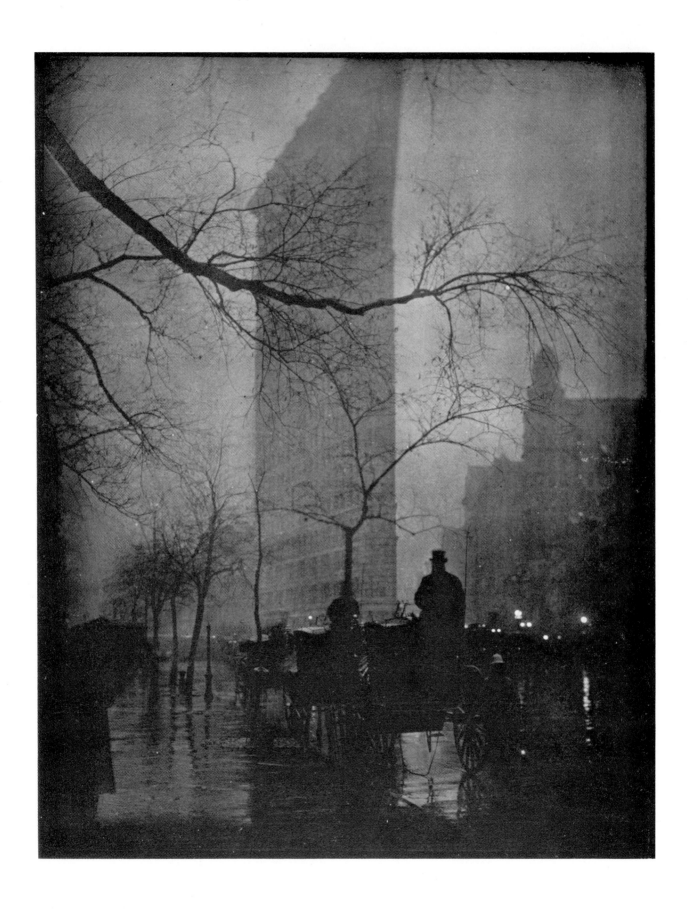

Eduard J. Steichen: *The Flatiron—Evening*

Robert Doty

PHOTO-SECESSION

Stieglitz and the Fine-Art Movement in Photography

With a Foreword by Beaumont Newhall

Dover Publications, Inc.

New York

PUBLISHER'S NOTE

For this reprint edition of *Photo-Secession* the portfolio section, which begins on page 65, has been expanded from 32 to 67 plates. The photographs are grouped by photographer; the order of photographers has been determined by considerations of chronology and style, with, for example, those artists working in more modern idioms nearer to the end of the selection.

All the illustrations in this book (except those on pp. 7, 18, 20, 29, 32 and 39) appeared in the pages of *Camera Work*. For this edition most have been reproduced from original issues.

Published in Canada by General Publishing Company,
Ltd., 30 Lesmill Road, Don Mills, Toronto, Ontario.
Published in the United Kingdom by Constable and
Company, Ltd., 10 Orange Street, London WC2H 7EG.

This Dover edition, first published in 1978, is an
expanded republication of the work first published by the
George Eastman House, Rochester, N.Y., in 1960.

International Standard Book Number: 0-486-23588-2
Library of Congress Catalog Card Number: 77-20467

Manufactured in the United States of America
Dover Publications, Inc.
180 Varick Street
New York, N.Y. 10014

FOREWORD: From the beginning, photography's position in the art world has been a challenge. Samuel F. B. Morse, on seeing Daguerre's daguerreotypes in 1839 called them "Rembrandt perfected," and persuaded the National Academy of Design to elect Daguerre an honorary member. Charles Baudelaire, on the other hand, condemned photography as the refuge of would-be-artists — even though his friend, the painter Eugène Delacroix, was so fascinated by the new medium that he became a member of the French Society of Photography.

For half a century photographers knocked at the doors of salons, seeking the admission of their photographs as works of art, to be judged by the same critical standards as paintings, drawings, etchings, engravings and lithographs. Many mistakenly took the easy course of imitation, and forced the photographic medium to resemble other kinds of graphic art. A few pioneers, of greater imagination and taste, clarified the problem; they began to formulate an esthetic based on the characteristics of the photographic process. In England, Peter Henry Emerson outlined in the 1880's a new approach, and began, singlehandedly, a valiant fight for the recognition of photography as an *independent* fine art.

At this point a young American, Alfred Stieglitz, found his lifelong work. Years later he wrote: "Photography is my passion; the search for truth my obsession." He determined not only to prove that photography was an art, but that it deserved the encouragement, support, criticism, and dignified presentation which the other arts enjoyed. His own photographs early won international fame for Alfred Stieglitz, but personal triumph was not his goal. He fought for an ideal. He relentlessly encouraged camera clubs, progressive art societies, and the photographic press to exhibit and publish the work of the few photographers who shared his dedication. Such an individualistic band could not long remain with the trammels of already-organized channels.

In 1902 Stieglitz announced the formation of a new society, the "Photo-Secession." Nothing like it had been seen before; it was an outpost of modern art. With his friends—Eduard Steichen in particular—Stieglitz was to demonstrate the place of photography in the broad stream of art. They did this by exhibiting the work of the members throughout the world, and by exhibiting in New York City, in the modest galleries of the Photo-Secession at 291 Fifth Avenue, the work of photographers from Europe and America. To define the position of photography, Stieglitz and Steichen soon found themselves exhibiting works of art in other media—and thus introduced to America many painters and sculptors who have since become world famous.

Beyond these activities, Stieglitz himself published a quarterly magazine, *Camera Work,* which put on record, in fifty numbers, the work of the Photo-Secession. In its pages were superb reproductions of what was shown at the galleries, with criticisms, essays, articles.

What Alfred Stieglitz and his colleagues accomplished spread far beyond New York City and the pages of *Camera Work;* it was not only the clearest and most convincing demonstration of the position of photography in the fine arts that has yet been undertaken in the history of photography, it was a revolution. Our appreciation and respect for the medium of photography owes its foundation to the Photo-Secession; the spirit which was created more than half a century ago has become tradition. Long after the Photo-Secession informally disbanded, Alfred Stieglitz continued to publish *Camera Work;* to the day of his death in 1946 he maintained a gallery for photographs and paintings; from him a stream of younger artists came in contact with a dedication

to truth, to standards, to ideals greater than they had ever experienced.

In its mission of establishing a continuing history of photography, the George Eastman House presented, from Oct. 22, 1959 to Jan. 15, 1960, an exhibition of a selection of the very photographs, paintings, drawings and lithographs which were shown to the public so many years ago by the Photo-Secession.

This book describes the background, the origin, and the work of the Photo-Secession, and the relation of this extraordinary movement to the history of photography. One has but to scan the photographic press of the world for the early years of the 20th century to realize the impact created by this group of believers in the art of photography. The text is based on original documents preserved by Alfred Stieglitz, now in the Library of Yale University. It is illustrated with reproductions from *Camera Work*. It is dedicated to the memory of Alfred Stieglitz, and to photographers everywhere who find in photography a way of life, and a search for truth.

BEAUMONT NEWHALL

ACKNOWLEDGMENTS: The following graciously made available the resources of the institutions they represent: Dr. Edgar Breitenbach, Chief, Prints and Photographs Division, Library of Congress; Mr. Hugh Edwards, Curator of Photography, The Art Institute of Chicago; Mrs. Edith Gregor Halpert, Director, The Downtown Gallery; Miss Romana Javitz, Head, Picture Collection, New York Public Library; Mr. Edward Steichen, Director, Department of Photography, The Museum of Modern Art; Mr. A. Hyatt Mayor, Curator of Prints, The Metropolitan Museum of Art; Miss Ruth Peyton, Registrar, The Albright Art Gallery.

I am particularly grateful for the use of the Stieglitz Archive. This important collection of the papers of Alfred Stieglitz was established by Miss Georgia O'Keeffe, and is deposited with the Yale Collection of American Literature. The Curator, Mr. Donald C. Gallup, gave invaluable assistance with the use of the resources in that Archive.

The reproductions are made directly from the pages of *Camera Work*. We are most grateful to Miss O'Keeffe for permission to use this copyrighted material.

For generous assistance thanks are also due Miss Doris Bry, Miss Elizabeth Buehrmann, Mr. Alvin Langdon Coburn, Mrs. Walter L. Flory, Dr. Carl Hersey, Mr. Daniel W. Jones, Jr., Dr. Howard Merritt, Nancy Newhall, Dorothy Norman, Mr. George Pratt, Miss Laura S. Seeley, Mr. Max Weber, Mr. Clarence H. White, Jr., and Mr. Lewis White. Special thanks go to Miss Grace Mayer for her valuable suggestions, information and encouragement.

The design of the book reflects the typography used by the Photo-Secession in their publications.

TABLE OF CONTENTS

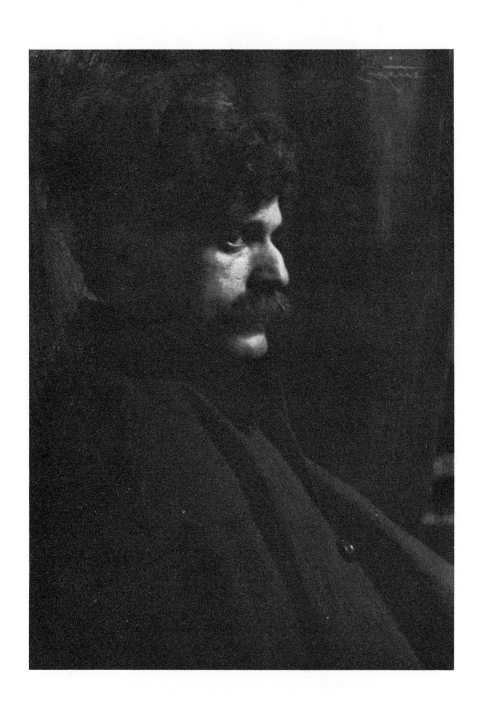

Frank Eugene: *Mr. Alfred Stieglitz* (c. 1898)

I. INTRODUCTION

PHOTOGRAPHY at the turn of the century enjoyed an immense popular enthusiasm, brought about by modern manufacturing methods, which turned out cameras and supplies in a steady flow to accommodate the "snapshooter." They in turn produced picture after picture, with seldom a thought for fine results. Photography was no longer the exclusive domain of the professional or those few dedicated amateurs who took the trouble to master a complicated technique. Yet the thread of craftsmanship in photography held firm, despite the onslaught of the "snapshot." In fact, it grew stronger as certain amateur photographers set out to prove that the camera could produce works of art. They held exhibitions to prove it. Their aesthetic endeavours with the camera aroused the scorn of such established artists of brush and pencil as the etcher and illustrator Joseph Pennell, who wrote of the amateur:

> "...Photography is his amusement, his relaxation. He labours in his pulpit or at his desk all week and then, when the half-holiday comes, he seizes his little black box, skips nimbly to the top of a bus, hurries from his Hampstead Heights to the Embankment, plants his machine in a convenient corner, and with the pressing of a button or the loosing of a cap, creates for you a nocturne which shall rank with the life-work of the master...!"[1]

Yet these attempts to evoke beauty from a creative process that had succumbed to the relentless speed and efficiency of modern manufacturing methods were not unusual. In New York, the National Arts Club, founded in 1898 by a group interested in stimulating the arts and improving the quality of manufactured goods, embarked on a series of exhibitions, which included pottery, rugs and other manufactured items, as well as the traditional fine arts. In line with this progressive outlook, the Club decided to hold an exhibition of "pictorial photography."

The exhibition opened on March 5, 1902, and extended through March 22. It was titled, "American Pictorial Photography, arranged by 'The Photo-Secession.'" For those who were baffled by the name "Photo-Secession," the catalog suggested that inquiries could be directed to Mr. Alfred Stieglitz, well-known amateur photographer and member of the Camera Club of New York, who had organized the show. The exhibition was a selection of photographs by thirty-one of the most prominent amateur photographers of the day, members of the very active camera clubs of New York and Philadelphia, who had recently exhibited these very same photographs at Glasgow, Paris, London and Munich. The press was enthusiastic, the New York *Sun* declaring, "This is not only the best exhibition ever held by the National Arts Club, but the best of its kind that has yet been seen in New York." The finest photographic publication of the day, *Camera Notes,* described it as "of an unusual importance to pictorial photography in that the unsolicited request of the National Arts Club betokens a beginning of that broader recognition for which *Camera Notes* has been striving so long."

The reporter for the New York *Sun* and the editor of *Camera Notes* both found the exhibition a milestone. And rightly so, for it marked the culmination of a concept that had been growing for over fifty years, despite extreme criticism, and kept alive by a few devoted individuals. It was simply: photography as a fine art. The exhibition at the National Arts Club was the first large-scale manifestation of this art form in New York City.

It was far from the first in America, and very far from the first in Europe. There, important exhibitions devoted exclusively to photography as a fine art had been

held in London since 1893. Moreover, exhibitions showing artistic, as well as scientific, commercial and industrial photographs had been in vogue since the 1850's. The significance of the exhibition held at the National Arts Club was not only that an institution devoted to the universal promotion of the arts accepted photography as a means of artistic expression, but that through this exhibition a new group of photographers suddenly found themselves crystallized into an organization, "The Photo-Secession," which was to lead a valiant fight for the recognition of photography as an art and, in the process, pioneer in exhibiting other forms of modern art in America.

II. THE BACKGROUND

THE aesthetics of photography have always been a subject for extreme, and often bitter, controversy. The relative ease of making an image, the fact that it is a process utilizing chemistry and machinery, its position, following the development and acceptance of the other pictorial arts, are points which have all been advanced against its acceptance as an art form. Yet from the start, daguerreotypists occasionally achieved aesthetic effects, especially in portraiture, and during the 1840's, began conscious artistic experiments by posing models and creating allegorical scenes. At the same time, in Scotland, a painter, David Octavius Hill, and a photographer, Robert Adamson, using the calotype technique, collaborated to produce a remarkable series of portraits, posed and lighted in the style of the paintings of the period, but seen with a directness characteristic of photography. In 1853, Sir William J. Newton, a painter, proposed that the camera could produce artistic results, and the method he suggested was to use the camera slightly out of focus, a practice that was to be very controversial fifty years later. But throughout the 1860's the photographic journals continued to debate the question, is it art, or is it science? A few photographers not only debated, but began to self-consciously practice photography as a fine art.

Oscar Rejlander, a Swede living in England, produced an allegorical composition entitled, "The Two Paths of Life," which he exhibited in 1857. It was a misguided attempt to emulate a style of popular allegorical painting. To produce it he departed from conventional photographic techniques: he took thirty separate negatives of a group of models and combined them to produce one huge print, depicting the virtues and vices. The same technique was employed shortly thereafter by Henry Peach Robinson, also working in England. He, too, drew upon the sentimental subject matter so popular with the painters of their day and posed models in such scenes as his first success, "Fading Away," which showed a bereaved family attending a dying girl.

In 1869 Robinson published *Pictorial Effect In Photography,* a course of instruction in aesthetics applied to photography, but relying heavily on principles derived from painting. It became a standard work on the subject. More text-books, and a flood of magazine articles, made Robinson the dominant figure in the attempts to prove photography a fine art. The critic Robert de la Sizeranne justifiably attacked his methods in an article for *The Chautauquan:* "Mr. Robinson also makes true pictures by grouping young girls from the city, disguised as country women in the fields . . . He was led to this step on account of the well-known difficulty of posing rural people . . . With his company of young society girls Mr. Robinson has avoided all this trouble. He is able to form exquisite rural scenes in which the natural does not exclude the picturesque . . ." These sham means of producing tableaux which would appeal to the popular desires for the superficial aspects of beauty were the dominant factors in what was gradually becoming known as "pictorial photography," that is, photographs which were intended to be beautiful, or tell a story, and which appealed directly to the emotions of the viewer. It became a very popular form of photography. As more and more amateurs took up photography, their societies and clubs began to hold exhibitions (the Photographic Society of London, parent of Royal Photographic Society, had its first exhibition in 1854, and continued to exhibit every year thereafter). More and more photographs made in the saccharine style of Robinson appeared, as the pictorial photographers sought to capture the "picturesque." It was a deliberate, conscious desire to create art with the camera, and still the battle raged, "is it art?"

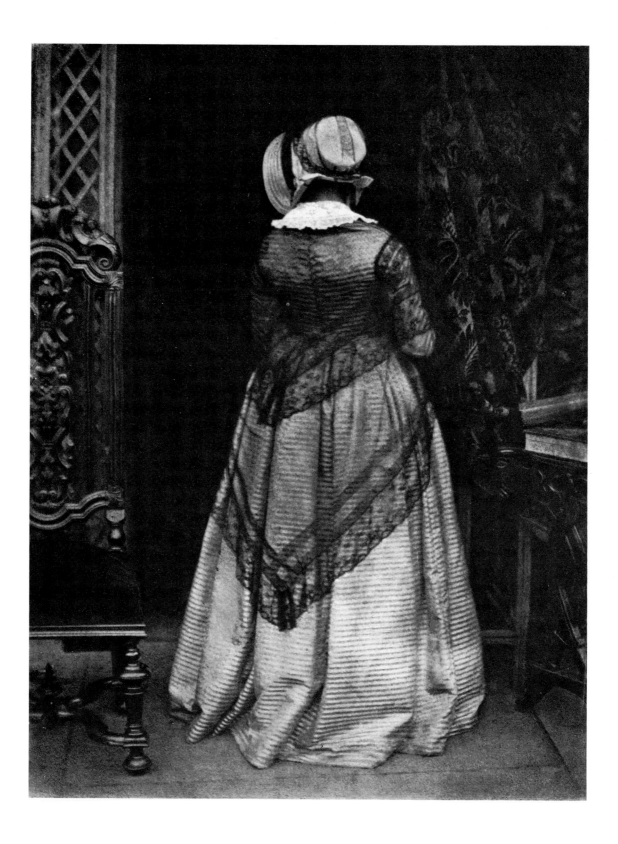

David Octavius Hill and Robert Adamson: *Lady Ruthven* (c. 1848)

In the 1860's, an amateur, Julia Margaret Cameron, began to photograph with remarkable sincerity and directness, Tennyson, Carlyle, Browning, and other celebrities. She revealed the inherent characteristics of the subject in these unusually frank portraits, although her attempts to illustrate Tennyson's poems and other allegorical subjects, were heavily influenced by the mannerisms typical of Pre-Raphaelite painting. She used the wet plate, or collodion, process, in spite of the awkward manipulations which it required, and which deterred many from becoming amateur photographers.

Gelatin was the saviour of the amateur. Its use as a suspension for light sensitive materials on the photographic plate was first discovered by Richard Leach Maddox in 1871, and by 1879 was perfected by other workers until it was the universal standard.

The dry plate, as it was called, was much faster than the wet-plate process, and made possible the use of the small hand camera, unleashing hordes of amateur photographers. Banding together in their mutual interest, they formed a multitude of camera clubs, where enthusiasts could meet to exchange information and ideas. The rapidly expanding number of photographic journals urged them on with news of apparatus, other clubs, and the idea that they could incorporate aesthetic concepts into their pictures. Exhibitions within each club gave the members the incentive to make images qualifying as "art."

In England, one of the best known amateurs was Dr. Peter Henry Emerson. Reacting violently against the artificiality of the faked, studio-type work promulgated by Robinson and Rejlander, he advocated a theory of photography based on optics and painting. He proved his theory by publishing superb prints, original platinotypes or beautiful reproductions of them, made in a clear, concise style which caught the essence of atmosphere in landscape or the essential character of a portrait study. However, his approach met with much controversy, especially that of "differential focussing." That is, he argued that the eye sees only a small part of the scene and that all else around it appears blurred. The photograph should reproduce this vision. This idea found a ready following and soon developed into a vogue for making photographs in the new "Impressionist" style. The photographic world, which, during the 1880's, was primarily England, split into two camps. One maintained that all parts of a photograph must be given perfect definition. Others, more prone to consider themselves artists, followed Emerson's theories. They deliberately threw their images, which were mostly of landscapes, partly out of focus. They were quickly labeled "the fuzzy school," or "the Naturalistic school," a term derived from the title of Emerson's book, *Naturalistic Photography*, first published in 1889. In it, he propounded his ideas, including differential focussing; it had an immeasurable effect on the ever increasing popularity of pictorial photography. By his writings and work he became the most important figure in pictorial photography at that time. He was called upon for advice and guidance and became a prominent judge at exhibitions. It was as a judge that he first saw the work of a young amateur named Alfred Stieglitz.

Stieglitz was an American, at the time resident in Berlin, where he was studying mechanical engineering. There he had been attracted to a camera in a shop window. Attraction turned to fascination and soon he had registered for a course in photochemistry under the brilliant Hermann Wilhelm Vogel, first professor of photography at the Technische Hochschule, Berlin. He began to experiment with photography, laying the groundwork for a complete mastery of the medium. He photographed constantly, especially while on trips through Europe; it was in Italy in 1887 that he made the photographs which he sent to a competition held by the English journal,

The Amateur Photographer. It was one of these that caught the eye of Dr. Emerson.

On June 20, 1888, he wrote to suggest that Stieglitz undertake a German translation of *Naturalistic Photography,* remarking that his photographs were "the only spontaneous work" he had seen in the competition. Stieglitz agreed to do the translation and, although it was never published, they enjoyed an exchange of ideas about it, and photography in general, through their letters. Stieglitz was now photographing continually, participating in photographic competitions and beginning to win the first of some 150 different awards for his photographs. Emerson encouraged him, and, as the English correspondent for the journal, *American Amateur Photographer,* even offered to secure for Stieglitz the position of Berlin correspondent. Early in their association Emerson had written to Stieglitz, inquiring whether or not he was an American, and upon receiving an affirmative reply, wrote back:

> "Shake — I am an American too — my father was a Massachusetts man one of the Emerson family — but we had better not say much about our nationalities this side of the water — especially in photo-circles, that is a tip..."[2]

America, just being over-run by thousands of photographers armed with the new Kodak, was woefully lagging in any attempts to explore the potentials of photography. The stiff, pretentious portraits made by the town photographer were often regarded as the height of photographic art. Those few writers who discussed photography in the popular magazines sometimes described this "art":

> "...get a good model, pose it in the studio, get a good negative of it, and then make a platinum print of the negative. This print is a basis for work. The accessories are painted in, the figure is idealized, and the result is an artistic photograph that is also a picture..."[3]

But the amateur photographer, free from any need to conform to the requirements of the market, was demonstrating new ideas. Clubs were being formed in America. The first to be organized in New York City expressly for amateurs was the Society of Amateur Photographers of New York, which held its first meeting on March 28, 1884. Its first few years were mainly given over to the demonstration of new equipment and processes, but the club had been organized for the promotion of the art, as well as the science of photography. On March 26, 1887, the photographic societies of Philadelphia, Boston, and New York, opened a combined exhibition of the work of the members of the three societies at the Ortgies Gallery in New York. This was the first of a series of what became known as "Joint Exhibitions," and which ran until 1895. They covered all aspects of the medium, the aesthetic being grouped under landscape or marine views, portraits, genre subject, and figure composition, while the technical side was included under enlargements, lantern slides, applied photography, scientific and technical. Entries to the first exhibition numbered over a thousand, and diplomas were awarded for excellence.

Moreover, entries were permitted from clubs throughout the United States and Europe. During the next few years in these exhibitions, the greatest revelation was the quality of the foreign work, especially from the English photographers.

Stieglitz, who had returned to the United States in 1890, achieved his first position of prominence in American photography in 1892 by accepting an editor's post with the *American Amateur Photographer.* In the May, 1893, issue he wrote; "... The work shown by Englishmen is proof positive that we Americans are 'not in it' with them when art photography is in question...Our best men would be about at the top of the second class in England...Of course, there were but few pictures shown which

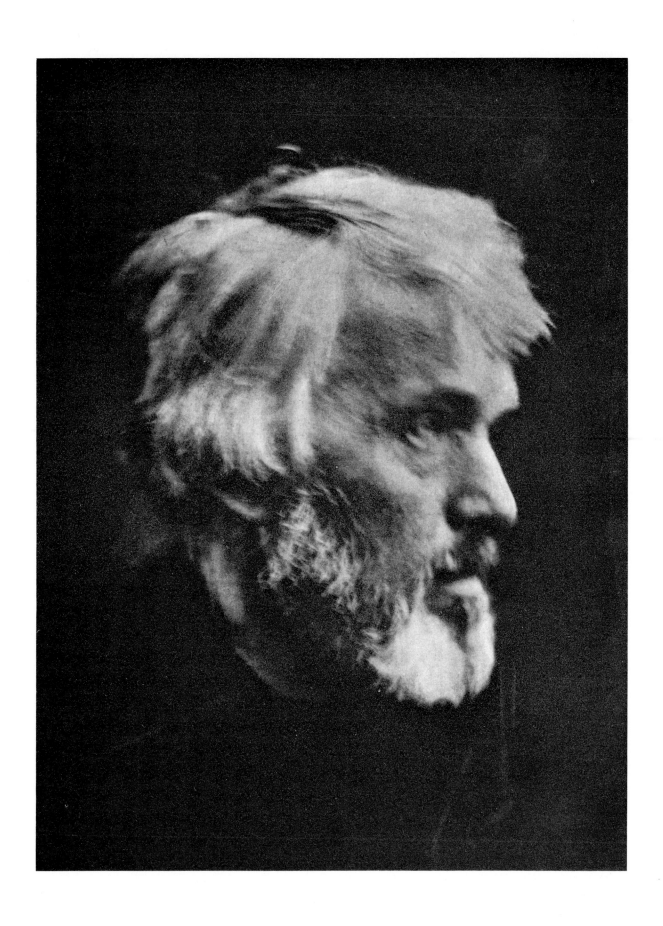

Julia Margaret Cameron: *Carlyle* (1867)

were of real art value; still there were some, and that is one tremendous step forward . . ."

More than any other group of the time, the English photographers worked to improve photography as a medium of expression. In their methods they were divided into two camps. Some preferred the teachings of Emerson and "naturalistic photography," while others practiced the more artificial techniques advocated by H. P. Robinson. Yet, despite these differences, leaders of both camps agreed that no institution was exhibiting photographs as works of art. The Royal Photographic Society, in its annual exhibition, showed all kinds of photographs together, technical and scientific, as well as pictorial. Finding no support within established means, five members broke away from the Royal and formed a group whose ideals were based on purely artistic aims. They called themselves "The Linked Ring." In 1893 they held their first exhibition in the Dudley Gallery, London. The principles of this exhibition were recorded in an article by George Davison, one of the members of the Linked Ring:

> "Many influences have been working for some years to bring about a more distinctly artistic system of photographic exhibitions in various countries. Until comparatively recent years photographers seem to have been content to interest themselves in the optical, and what is called the technical perfection of their method of representation or imitation of nature. . . . The backbone of this exhibition is no medals and rigid selection. . . . Every style is to be seen in the selection on the walls, that is every style applicable to artistic representation . . . The exhibition ought to prove the death of the old style of show where mechanical, scientific and industrial exhibits are all jumbled up together with very little distinction . . ."[4]

This was prophetic. The London Photographic Salon, as it came to be known, established a standard for photographic exhibitions the world over. It quite justifiably accomplished the objects of its designers to ". . . give to pictorial work in photography a place of its own, and to set a standard of value." By doing away with medals, the Salon placed new emphasis on the quality of the work. The Linked Ring brought new design methods to the hanging of photographs and continually worked for the improvement of standards within the medium. Before long it was the leading group in pictorial photography. To be elected a member was considered a great honor.

Meanwhile, at the same time, the pictorial movement was gaining strength in other countries of Europe as well. In 1894 the Photo-Club de Paris held its first Salon, where for the first time in France photographs were shown for their aesthetic value, and gradually the German photographers began to take up pictorial photography.

III. STIEGLITZ AND AMERICAN PHOTOGRAPHY

IN America, interest in pictorial photography was strong among the amateur photographers, but there was very little outlet for it. After the initial spurt of growth, most camera clubs had stagnated. The Joint Exhibitions died of apathy and jealousies occasioned by the practice of awarding medals. Among the club members this probably caused little remorse, but there was one voice willing to speak for pictorial photography. As editor of the *American Amateur Photographer,* Alfred Stieglitz was in position to take up the battle for the art to which he was to devote his greatest efforts. In the pages of his magazine, he insisted on publishing only the finest pictorial photographs. Time and again he sent back contributions with the terse comment, "technically good, pictorially rotten." He began to work for the establishment of a Salon, run on the lines of those held so successfully in Europe, believing that it was only by seeing and comparing their work with that of others, especially Europeans, that the pictorial photographers in America could progress. His faith in the medium was strong as he wrote for a European review in 1895, ". . . Fortunately there are some enthusiasts and hard-workers left who keep the flame a-burning; their endeavours will be rewarded in due time."

One of these enthusiasts was E. Lee Ferguson of Washington, D. C., a member of the Camera Club of the Capitol Bicycle Club. With much enthusiasm, he set forth in 1896 to organize a photographic Salon. But the result was a Salon in name only. Bowing to pressure from the other club members, he was forced to establish two classes: one, for photographs made as beautiful images, the other for those judged solely on technique. Despite appreciative comments by the photographic press to the effect that ". . . present tendency of photography, especially among amateur workers, is in the direction of artistic production," Stieglitz could only regard the exhibition as ". . . somewhat of a cross-breed between the new and old ideas" and regretted that the word Salon had been applied to it. For too long photography had been regarded as a simple and easy pastime, picture making for everyone. Stieglitz realized that recognition for pictorial photography as a fine art could only be based upon the same high values and standards as those of the other graphic arts. The problem was to demonstrate that it could be a serious form of expression as well as a fad.

Stieglitz' own photographs were a constant affirmation of creative power. He experimented constantly, with both technical and aesthetic problems. Chemicals and papers that were considered impractical, he used to produce prints with salient tonal qualities that demonstrated the means to a potential aesthetic. The lantern slide, spurned as a toy and parlor amusement, he made into a thing of beauty. With his researches in photographic technology he merged new methods and new approaches to the manner of visualization, which Charles Caffin later described in his book, *Photography as a Fine Art:*

> ". . . He is by conviction and instinct an exponent of the "straight photograph," working chiefly in the open air, with rapid exposure, leaving his models to pose themselves, and relying for results upon means strictly photographic. He is to be counted among the Impressionists; fully conceiving his picture before he attempts to take it, seeking for effects of vivid actuality and reducing the final record to its simplest terms of expression . . ."[5]

He was a member of the Society of Amateur Photographers of New York and participated ceaselessly in the activities of the club. He wrote many papers about his

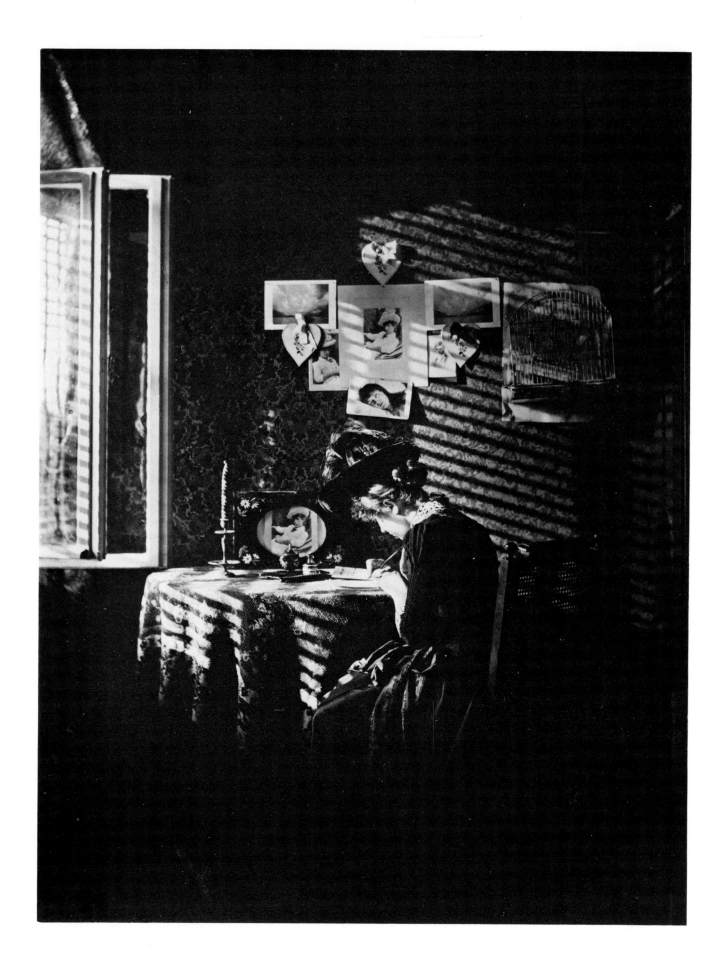

Alfred Stieglitz: *Paula, Berlin* (1889)

experiments in photography for the benefit of his fellows. His rapidly growing reputation as a medal-winner in international photographic competitions earned him positions as a judge in club competitions, and he produced the catalogs for the club exhibitions. But despite his support and that of the other members, they found themselves faced with a mounting debt. Salvation came from the members of the New York Camera Club, who had funds, but only a waning enthusiasm for photography. On May 7, 1896, the two clubs merged to form the Camera Club of New York.

Stieglitz still cherished the idea of a dignified exhibition for pictorial photography in America. The Camera Club seemed to hold promise as he wrote, ". . . we have every reason to believe that the new society . . . will, in the near future, undertake an 'International Salon,' which is to bring together the very best work only from all countries." But this was not to be. Stieglitz resigned from his post on the *American Amateur Photographer,* in January, 1896. A little over a year later he had found his new place. Taking over the old *Journal of the Camera Club,* he created the finest publication the photographic world had yet seen: *Camera Notes.* In the first issue, dated July 1897, Stieglitz established the policy toward which he had been working:

> ". . . to make it more acceptable to our members, possibly to reach a class outside the membership, and to stimulate them to artistic effort, it is proposed to publish with each number two photogravures representing some important achievement in pictorial photography; . . . In the case of the photogravures the utmost care will be exercised to publish nothing but what is the development of an organic idea, the evolution of an inward principle; a picture rather than a photograph, though photography must be the method of graphic representation. . . ."[6]

For the first time, there existed a publication which could emphasize the finest aspects of photography. Stieglitz now had a means of bringing before the public work to exemplify the high standards of aesthetic excellence which he demanded. And the support was there. From his friends and associates in the Camera Club, and the photographers in Europe, came the photographs, which in the pages of *Camera Notes,* demonstrated that there was indeed a striving for art among the photographers. Landscapes breathing atmosphere and light, mysterious allegorical figure studies by the Boston photographer, F. Holland Day, picturesque genre studies, and true portraits, which put life and character into the subject, were presented to the readers of *Camera Notes.*

A new spirit was reflected by the membership. Stieglitz inaugurated a series of one-man shows at the Camera Club rooms, including Gertrude Käsebier, Joseph Keiley, Charles I. Berg, Rudolf Eickemeyer, Jr., F. Holland Day, John E. Dumont, and Frances B. Johnston, among others. These exhibitions were open to the public, and to bring the work of the members to an even wider audience, the Club began the publication of portfolios of outstanding photographs.

All the while *Camera Notes* continually published the finest photographic work of the day. Throughout America and Europe it began to arouse photographers to the expressive potential of the camera.

But the Camera Club never realized the proposed international exhibition. This was reserved for another, and equally flourishing camera club, the Photographic Society of Philadelphia, led by Robert S. Redfield and John G. Bullock. With the promise of their support, the Pennsylvania Academy of the Fine Arts initiated the idea that a photographic exhibition be held in their galleries. As the Philadelphia press noted, this was the first photographic exhibition to be held under the auspices of a recognized

CAMERA NOTES

OFFICIAL ORGAN OF THE CAMERA CLUB, N.Y.

PER YEAR $1.00

PUBLISHED BY
THE CAMERA CLUB, N.Y.
3-7 WEST 29TH STREET
NEW YORK CITY

Cover of *Camera Notes*, Vol. 1, No. 1 (1897)

fine arts academy. It opened on Oct. 24, 1898. The catalogue of the exhibition stated that "...the possibilities of photography as a method of artistic expression are now generally admitted," and that "...the purpose of the Salon is to show only such pictures produced by photography as may give distinct evidence of individual artistic feeling and execution."

Commenting on this criterion, Joseph Keiley, one of the exhibitors, wrote for *Camera Notes:* "For the first time it was realized that a Stieglitz, a Hinton or a Day was as distinctive in style as a Breton, a Corot or a Verestchagin;* that photography is open to broad as well as sharp treatment; that it had its impressionists and its realists..." Although there was a fine representation of subject matter, the number of contributors from abroad was disappointingly low. The main support of the exhibition came from New York and Philadelphia, but a number of entries appeared from isolated workers throughout the country. One of these was a young clerk in a Newark, Ohio, grocery firm, named Clarence Hudson White. His photographs of young girls in fields and at home, his friends and family depicted in a direct, naive style, were a fresh new approach to expression through photography. Self-taught, his only mentor had been the reproductions he saw in *Camera Notes.*

An enormous success, the Philadelphia Salon was eagerly repeated the next year. This time the same aesthetic standards were enforced, and for the first time the jury of selection was composed entirely of photographers. No longer did they consider it necessary to have painters as members of the jury, to certify their work as art. Keiley remarked in his review of the year for the English annual, *Photograms of the Year 1900,* that at last there was evident a distinctly American school of pictorial photography. Other clubs took note, especially of one particular photographer.

> "...The impressionist school was not as largely represented as it was thought it would be, although there was at least one example which it seems as though the jury must have selected more out of pure love of fun than anything else ...This photograph, which was entitled 'The Frost-covered Pool' was the product of Edward J. Steicher [sic], Milwaukee, Wis. . . . While there were a few other photographs that might be classified as belonging to the impressionistic school, still they were not of the ultra type, of the type that shows so little that it is not even worth while to guess at what the camera was levelled..."[7]

Eduard J. Steichen (as he then spelled his name), was living in Milwaukee, apprenticed to a lithography firm. He, too, was self-taught, guided by the reproductions and teachings he saw in *Camera Notes.* The Chicago Salon of 1900 was his first attempt at a public showing of his work. Not all the critics were so severe. William B. Dyer, also a photographer, remarked that "His future was sure to be most interesting," and Clarence White noted his work, writing to Stieglitz:

> "...I have a letter from Steichen of Milwaukee giving his opinion of the Chicago Show. He is a very interesting fellow judging from his pictures and his letter. He starts for Paris in a couple of weeks and shall write him to call and see you in New York..."[8]

Almost all aspiring artists in America sought training in Europe. As far as the art world was concerned, America was still a colony. Steichen was going to Europe to study painting, but after seeing Stieglitz in New York and receiving his encouragement he vowed never to give up photography. In Steichen, the two talents co-existed, the

*Vassily Vassiljewitsch Vereshchagin, (1842-1904), Russian genre painter, whose "Life of Christ" series was exhibited in New York in 1886.

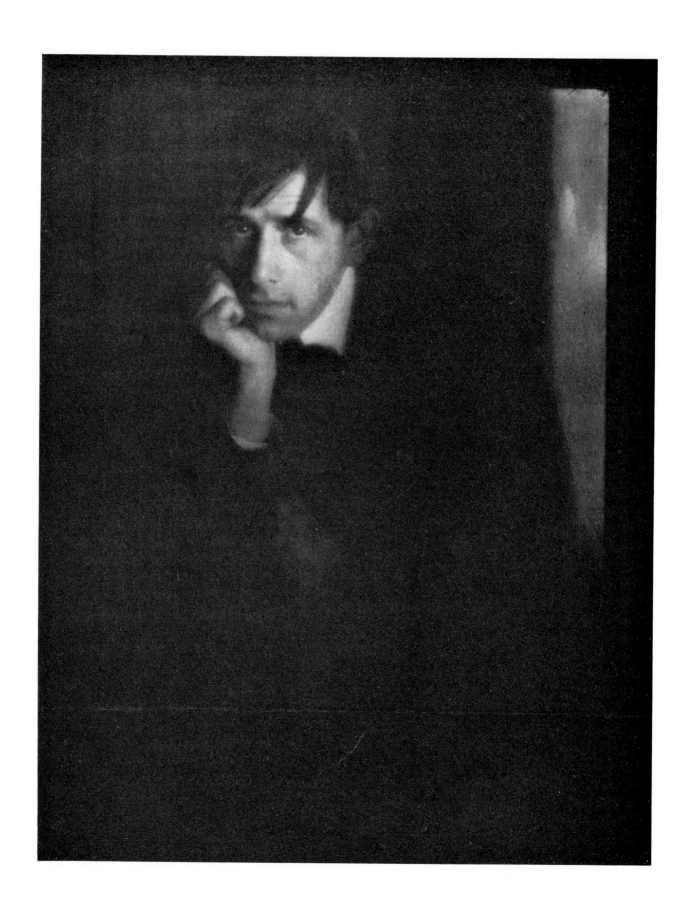

22 Eduard J. Steichen: *Portrait of Clarence H. White* (1903)

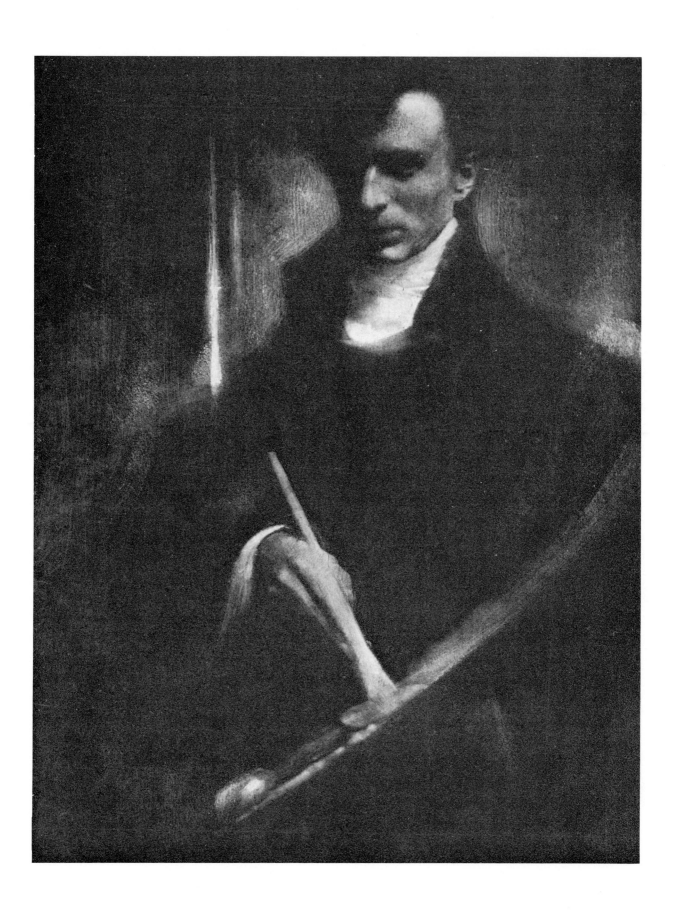

Eduard J. Steichen: *Self-portrait* (1902)

living proof, especially to Stieglitz, that photographer and painter could produce work of equal power.

In Europe, whose artistic life Steichen now joined, the tide of battle was turning much faster. The Linked Ring and The Photo-Club of Paris had been holding their exhibitions every year. Now, several international art expositions were recognizing pictorial photography by including it as a fine art.

In Germany, a number of artists, reacting against the Academy and supporting a more naturalistic style, formed the "Secession." Through their exhibitions they sought to inject new ideas and a new spirit into German art. As an innovation, the Munich Secession hung photographs along with their paintings in their exhibition of 1898. This example was later followed by the Secessionist painters in Vienna. At almost the same time, photographs were being sent to the Glasgow International Exhibition, where they were judged with the same care as paintings, architecture and sculpture. Coincidentally, American photography was winning rapid acceptance at the greatest of all trials, the London Photographic Salon.

George Davison, one of the founding members of the Linked Ring, remarked after seeing The London Salon of 1899, that the most remarkable development came from the American exhibitors. Tired of the same clichés that had been on view every year since 1893, most critics reacted favorably to the American work. One remarked that:

> ". . . the American school, in the restricted modern sense, represents, if we read its works aright, a protest against the niggling detail, the factual accuracy of sharp all-over ordinary photography. That wealth of trivial detail which was admired in photography's early days and which is still loved by the great general public whose best praise of a photogram[9] is that it is 'so clear,' has gone out of fashion with advanced workers on both sides of the Atlantic. Concentration, strength, massing of light and shade, breadth of effect, are the highly prized virtues..."[10]

Another reviewer spoke of the "unerring tonality and unity," admired the work of Clarence White particularly, and drew attention to the influence of Whistler. Only the ultra-conservative *British Journal of Photography,* seemed aghast at what was happening and spoke scathingly of "hysterical foolishness" and bragged, "We saw it coming — this Cult of the Spoilt Print." The critic's particular target was the work of F. Holland Day, and not without good reason. Day delighted in dressing his subjects, particularly Negroes, in exotic costumes, portrayed in deep shadows to illustrate allegories. He was heavily censured by the English critics for his religious themes. But it was Day who was to complete the American "invasion" of the European exhibitions.

In February, 1900, Day had written to Stieglitz, indicating that he intended to counteract the patronizing attitude with which the European photographers regarded the work of their American counterparts. Day offered to defer any attempt on his part to whatever Stieglitz might wish to do; however, later in the year he sent a circular letter to a number of American photographers, requesting that they send him examples of their work for possible exhibition purposes. On July 27, 1900, the members of the Linked Ring were called to a special meeting, to consider whether or not to accept Day's offer of a collection of some three hundred photographs for exhibition in the coming London Salon. They declined, due to a hasty interchange of letters and cables between A. Horsley Hinton, Editor of *The Amateur Photographer,* and Alfred Stieglitz, a member of the Linked Ring since 1895. On July 31, 1900, Hinton wrote to Stieglitz:

"Your cable received today, 7:30 P.M., *most opportune,* as the Linked Ring met to decide finally the Day affair at 8:30 . . . I communicated immediately with Craigie, also George Davison, an *informal* meeting was held, and half a dozen practically *agreed to accept* Day's collection and hang them on a distinct and separate screen *as a loan collection.*

This would have been passed and settled tonight *but for your wire.* Armed with this I put it that the fact of a cable implied serious intent, and when I put it as (pending your letter) it was Stieglitz versus Day, I had *no difficulty* in getting a verdict to 'await Stieglitz' letter' . . ."[11]

Day was undaunted by the Linked Ring's refusal to show his collection. He promptly offered it to the Royal Photographic Society. On Oct. 10, 1900, the exhibition opened as, "An exhibition of prints by the New School of American Photography, supplemented by an additional collection of one hundred examples of the work of F. Holland Day, of Boston, U.S.A." The reception accorded the exhibition by the British photographic press was enthusiastic, and it moved on to an equally enthusiastic reception at the Photo-Club of Paris early in 1901, where again it was shown under the title of "New American School." It was unquestionably the final move in establishing the reputation of American pictorial photography before the previously hostile stare of the European public and press. If critical success was needed to establish an art form, the photographers had it now.

That the exhibition was well received was due to the strength of the photographs, but in Stieglitz' opinion, Day had not secured an adequate representation of American photography. For this reason he had taken steps to prevent it. Now, in America, he was to take still further action to establish his demands for pictorial photography and the respect it deserved.

Anything new is bound to feel the effects of criticism. So it was with pictorial photography. As early as volume two, members of the Camera Club were complaining about the aesthetic leanings of *Camera Notes.* "A growing and very dangerous Tarantism has inoculated the club. . . . Photography has no legitimate field except impressionism and sensationalism," was the opinion expressed by one member in a letter published in *Camera Notes.* As a result Stieglitz called a meeting of the club to discuss the policies of the magazine, and received an overwhelming vote of confidence. But the seeds of dissension had been sown.

In Philadelphia there was even stronger opposition to pictorial photography. There, too, those who thought that photography was being imbued with "a little too much art" were determined to have their day. A political battle took place within the membership of the Photographic Society of Philadelphia, with the result that the management of both the club and the Salon were replaced. The new officers were known to favor the "popularizing" of the Salon.

Their argument asserted that the Philadelphia Salon had been dominated by a clique and that it was time to seek a larger representation of the work being done throughout the country. The critic Charles Caffin summed up the situation, ". . . should the Salon be a nursing school for budding talent or an assemblage of the very best work that has been accomplished?" But it was too late for argument. All the recognized pictorial photographers, except F. Holland Day, refused to participate in the fourth Philadelphia Salon. Their position was summarized by Joseph Keiley, writing in *Camera Notes:*

". . . All who are seriously interested in the welfare of this pictorial movement in the United States had come to recognize the absolute necessity of establishing

some uniform standard of excellence for the entire country that would be considered authoritative. This could be brought about in one way only, by the recognition by all serious workers throughout the country, of some one of the many exhibitions held annually as the exhibition of the year, and by giving that their fullest support..."[12]

It was the end of the Philadelphia Salon. Stieglitz did some figuring on the back of his catalogue and wryly noted that "only 33 exhibited *before* at any Salon." The Pennsylvania Academy of Fine Arts, faced with the dreary prospect of again showing second rate photography, refused to hold the show. It was now the Fall of 1901. Stieglitz, assessing the hostile pressure towards pictorial photography that had infiltrated the Philadelphia Photographic Society and killed the Philadelphia Salon, realized that the high standards and desires that he held for photography as a means of expression could no longer gain support through the camera clubs. But where to turn, how to carry the case to the public?

This thought must have crossed Stieglitz' mind many times during the years 1900-1901. The squabbles over the Philadelphia Salon had made him realize that salons were not the answer. Many of his friends thought so too. Eva Watson, a photographer from Philadelphia, wrote to him on April 21, 1901:

"...make use of the three first Salons as the foundation for an American Salon expanding your idea of privileged exhibitors for an organization ... There could be associates also who would help swell the fund. Surely fifty people at least would be ready to join such a Society — where there would be little chance to accuse anyone — jury or exhibitors of favoritism ..."[13]

Stieglitz had also discussed with F. Holland Day the possibility of forming a small group of dedicated pictorial photographers. Sometime in 1900, Day approached Stieglitz with the suggestion that the trustees of the Boston Museum of Fine Arts might be agreeable to the idea of a photographic exhibition. With the help of a friend, Mrs. Sarah Sears, he secured the cooperation of the Museum and the promise of a gallery. He at once suggested to Stieglitz that an "American Association of Artistic Photography" should be formed to hold an exhibition. Stieglitz evidently demurred, preferring to wait for an opportunity to hold the exhibition in New York. Toward this end he began to make inquiries, for on Nov. 23, 1901, he received a letter from Charles Caffin, informing him of the cost for engaging Durand-Ruel's gallery in New York, and suggesting that they hold a meeting of interested people.

But he had already found his chance. On Nov. 15, 1901, he had received the following note from Charles de Kay, Managing Director of the National Arts Club:

Dear Sir:

February will do very well for an exhibition of select artistic photographs, and I understand that you will yourself give us during the course of the exhibition, on some Wednesday Night, a talk about Artistic Photography..."[14]

The opportunity to present, in New York, an exhibition under his complete command was at hand. Now came the problem of gathering support. He began to send out requests for entries. From their replies it is obvious that the photographers anticipated another Salon, and a new association. This caused some consternation among the established clubs. On Jan. 16, 1902, John Aspinwall, President of the Camera Club, wrote to Stieglitz:

"...I have been thinking over what you said the other day relative to the group of pictorial photographers and their patrons, and it strikes me that a nebulous body such as you proposed would eventually solidify around a common centre.

I anticipate that common centre would be a new 'Camera Notes' edited by yourself, in which case their gain would be our loss . . . I cannot imagine that you seriously believe that an aggregation of pictorial photographers could be held together, to accomplish any distinct work, by such a loose organization as you proposed to me the other night. I make a guess that it is only the preliminary step to the gathering together of the pictorial photographers into a more solid organization, and we should lose you and your friends from the Camera Club . . ."[15]

IV. THE PHOTO-SECESSION

THE "Photo-Secession" was founded on February 17, 1902. The exhibition at the National Arts Club was their first manifestation and it really marked the birth of the new group. Stieglitz had his exhibition at last, and those he had asked to contribute to it were allied in spirit, if not yet in a formal organization. In conversation with de Kay over the question of a title for the show, Stieglitz had hit upon "American Photography arranged by the 'Photo-Secession.'" At that point the name "Photo-Secession" stood more for a concept, than it did for a group of photographers. They would prove that pictorial photography was completely different from any other type, that it was an art form capable of standing by itself. In this he was allying himself and pictorial photography with the Secession movement in the art circles of Germany, which was proving that art could be alive and different. This idea he proceeded to apply to those photographers with whom he felt a spiritual kinship, and whose work expressed a desire to create through photography.

The interest generated by the exhibition at the National Arts Club, both on the part of the public in general and the photographers, was reflected in a number of articles in the photographic and popular press. One of the exhibitors, C. Yarnall Abbott, writing for *La Revue de Photographie* in 1903, stated that he and most of the other exhibitors, were "astonished" to see that the exhibition had been "arranged by the Photo-Secession." They, too, asked "what is the Photo-Secession?" It was a bewildering situation, for at first there was no ostensible organization of those photographers who exhibited their work under the name "Secession." This was done quite deliberately by Stieglitz, for he had no desire to do anything which might injure the Camera Club. He had resigned as Editor of *Camera Notes,* in the Spring of 1902, and he did not want the Secession to appear as a rival body to that of the other photographic associations. But, in the ever increasing number of statements about the Secession which Stieglitz made in the next few months, he declared "Its aim is loosely to hold together those Americans devoted to pictorial photography in their endeavor to compel its recognition, not as the handmaiden of art, but as a distinctive medium of individual expression." As the leader of the group, Stieglitz, by such statements, cut away all ties with existing photographic societies. Vindication lay in the photographs by the Secessionists.

During the years of training in the camera clubs and photographic societies, those photographers now allied with the Secession had worked toward a photography that went far beyond commonplace record, to expressions of beauty and spirit. Technique, once mastered, became unimportant, and the result had to be more than just an image on paper. Composition, massing of light and shade, correct rendition of tonal qualities, arrangement of lines, development of curves, were the means. With them they sought values, textures, character, any aspect which would appeal to the emotions of the viewer. Gradually there emerged a style which depended upon the relation of light and color, the softening of sharp lines, and particularly the suppression of details to obtain an impression. This was called "pictorial effect." It was quite frankly patterned after the styles of the currently venerated painters, especially Whistler, Corot, and members of the Barbizon School, Millet in particular. These painters softened their brushwork to achieve atmospheric effects of an almost scientific kind. Indeed, much of pictorial photography was a conscious emulation of pictures made by the brush, the pencil, or the etcher's burin. Because of the general criticism that photography was made by a machine, the pictorialists felt compelled to prove their work was similar to those

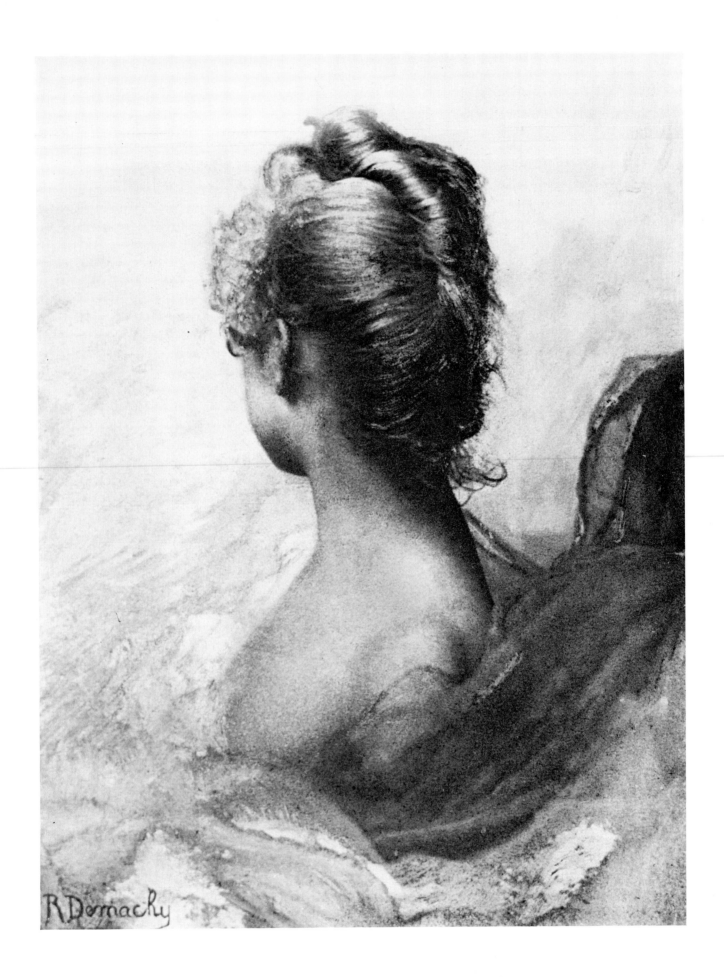

Robert Demachy: *A Study in Red* (c. 1898)

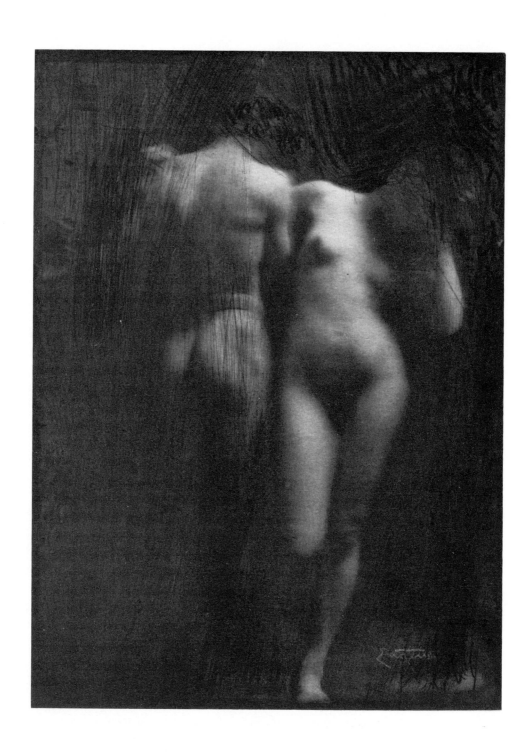

Frank Eugene: *Adam and Eve* (c. 1910)

graphic arts done by the hand. Hence, they adopted extreme techniques to achieve surface effects comparable to the textured quality distinguishing hand work.

"Enthusiasts of the Photo-Secession quote William Morris, who once said: 'Get the effect, no matter how — empty an ink-bottle over it if you like, but get the effect that you want. It is nobody's business how you get it'...," was the way that Howard Conway summed up the techniques used by the Secessionist photographers, for the readers of *Munsey's Magazine.* As pictorial photography grew, it fostered a number of new techniques. They were primarily methods for making the print, and enabled the photographer to eliminate the sharp, optically-correct image, and produce a picture intended to resemble an etching or a drawing.

In France, Robert Demachy demonstrated the gum-bichromate process in the early 1890's. In this process, paper was coated with a mixture of gum and pigment, which was sensitized with a potassium bichromate solution. In the operation of printing it was possible to strengthen or reduce parts of the image or completely remove them simply with hot water. The print could be any color, and even recoated again and again. This method gained considerable popularity, especially among the French, German, and Austrian pictorial photographers, and in America, through the work of Eduard Steichen. By allowing the photographer to manipulate his print by hand it avoided the stigma of the machine. It also allowed the photographer extreme latitude in removing detail and inserting what was not on the negative.

The platinotype process was particularly favored, especially after Alfred Stieglitz exhibited prints of superb tonal quality made by it. To this process, Joseph Keiley, working with Stieglitz, brought the modification which became known as the glycerine process. In this process also, the photographer could obtain greater modification of his print by use of the hand; by brushing the print with glycerine, the parts touched could be restrained in development. In fact, glycerine could be used to do away with parts of the image altogether. But the most extraordinary license with the photographic process was taken by Frank Eugene. Reviewing an exhibition of the photographs of this painter turned photographer, his colleague Dallet Fuguet, wrote:

> "...Mr. Eugene does not work on the prints in any way, but his negatives must be in a state which the ordinary photographer would consider shocking. He apparently rubs away and scratches the secondary high-lights that he desires to subdue; and he uses pencil and paint on the shadows he would lessen or lighten. He modifies and changes details in the same way, and all with a frank boldness..."[16]

The "ordinary photographer" was quite shocked, not only by the photographs made by Frank Eugene, but by the attitude and work of the Photo-Secession in general. When Stieglitz stated that the Photo-Secession was a protest against the "conventional concept" he meant the professional as well as amateur. A staunch Secessionist, and recognized professional portrait photographer in her own right, Gertrude Käsebier, scathingly denounced the standard professional methods:

> "...Who has educated the public to a false standard in photography? Who sanctions the painted background, the papier-mache accessories, the high-backed chair, the potted palm, the artificial flowers in the studio? There is one prominent photographer in New York who never need sign his productions for the sake of identification. The same Turkish cushion, the same muslin rose, appears in all his photographs of society women..."[17]

The Photographer's Association of America turned a deaf ear on such advice, and their members muttered about "that class who have hitched their outfits to the

Camera Work

THE MAGAZINE WITH-OUT AN "IF"—FEARLESS—INDEPENDENT—WITH-OUT FAVOR □ □ □

BY MARIUS DE ZAYAS

Marius De Zayas: *Alfred Stieglitz and* Camera Work (c. 1910)

idealistic star of art." Nor were a great number of amateurs overjoyed that the Photo-Secession was establishing pictorial photography as a fine art. The "rank and file" believed in the opportunity to submit their work before the jury of each exhibition, and regarded the Secession as exclusive and autocratic. All of which caused R. Child Bayley to voice the English view of American matters in his magazine, *Photography:* "there is no civilized country in which pictorial photography is held in less esteem, if we are to judge by the tone adopted by the photographic magazines." Obviously the first role of the Photo-Secession was to be a missionary one.

His long experience with photographic journals led Stieglitz to still another publication. On Aug. 25, 1902, he announced plans to publish *Camera Work.* It was, he said, the response to many requests. It was to be a quarterly devoted to the further-ance of modern photography and was to be published and edited by himself. He pledged himself to "reproduce the best examples of all schools, both American and foreign, in a style which will make the magazine of great value for its pictures alone, even to those who may not be interested in the literary contributions." Associate Editors were Joseph T. Keiley, Dallet Fuguet, and John F. Strauss. The first issue, dated January, 1903, carried the statement that it appeared as the "logical outcome of the evolution of the photographic art." It also stated that because the beauty of a photograph depended on subtle gradations of tone and value, every care would be taken with the reproductions. (These were usually photogravures printed on Japanese paper and tipped into the magazine by hand. They quite often surpassed the quality of the original.) It went on to state rather paradoxically that it owed allegiance to no organization or clique, though it was the mouthpiece of the Photo-Secession. It was indeed much more than that. In the next few years its pages were continually filled with articles on many aspects of art, as well as photography, written by noted critics, among them, Charles Caffin and Sadakichi Hartmann. It also contained articles by the foremost authors of the day, such as Maurice Maeterlinck and George Bernard Shaw. Its reproductions, beginning with representative portfolios of the work of such well known photographers as Gertrude Käsebier, Eduard Steichen, and Clarence White, often included new and exciting discoveries.

Meanwhile, the Photo-Secession also began publication, in December, 1902, of a small news-sheet. By now it was organized into a Council, composed of a Director and twelve members, with two classes of membership, Fellows and Associates. By July of 1903, it had collected 47 members. They lived in widely separated areas and the news-sheet performed the valuable service of informing them about participation in the many photographic exhibitions. Any member was free to contribute his work to any exhibition at any time he so chose. However, Stieglitz realized that the strength of their ideal depended on their working together as a body. Exerting an autocratic control over the members, he demanded, and received, only their finest photographs, which he submitted to the exhibitions. As a group, their first recognition came almost immediately when the King of Italy awarded his prize, the only one of its kind, to the collective exhibition of the Photo-Secession sent to the International Exposition of Modern Decorative Art, held in Turin, Italy. Immediately Stieglitz began a system of sending out collections of Secession photographs. These were sent under strict terms: the collections were to be hung as a unit, were not to be submitted to a jury, and were to be listed in the catalog as "Loan Exhibition of the Photo-Secession." Such terms brought forth denunciations of the Secession as a dictatorship, but requests for the loans began to come to Stieglitz in a steady stream. By the end of 1903, he had received one hundred and forty seven requests. They were usually judged as to the

intent of their management, and the benefit a loan could bring to the "cause." For instance, the news-sheet carried the message that the Chicago Salon had invited the Secession to contribute, therefore, "special effort should be made to make this collection so worthy as to bring conviction to the Philistines."

Such decisions were not always so easily resolved. The organizers of the Saint Louis Exposition, 1904, felt that photography should be included as one of the liberal arts, but refused to hang it in the fine arts building, relegating it instead to the industrial section. Stieglitz flatly refused to accommodate the exposition under those circumstances, pointing out that other expositions had already displayed photography as a fine art, not a craft, so why should they fight a battle already won? This refusal stirred up a rousing controversy in the photographic press, and again hot accusations of dictatorship were applied to the Secession. But Stieglitz stood firm. By demanding respect for the integrity of the medium he was raising it above the rut of popular fad to the dignity of a significant art form.

In 1904, his position was vindicated by the opportunity to hold two important exhibitions. In Washington, Norman W. Carkhuff, with the Capitol Camera Club, arranged an exhibition in the Corcoran Art Galleries. Although held under the auspices of the local organization, the exhibit was arranged by the Secession and was hung by Stieglitz and Steichen. In February, 1904, an equally important exhibition was hung in the Department of Fine Arts of the Carnegie Institute, Pittsburgh. It was seen by 11,000 visitors in three weeks. It was also a good example of the Secession policy of inviting unknown photographers to show their work along with that of the Secession, for one of the contributors at Pittsburgh was a young man named Alvin Langdon Coburn.

He was not a newcomer to photography however, for he had begun studying photography as a boy while living in Boston. There, he worked with his cousin F. Holland Day in the latter's studio. He assisted Day in his photographic enterprises and had the first showing of his work in the exhibition which Day hung in London in 1900. Coburn traveled extensively, studying in Europe, and in the United States with the painter Arthur W. Dow. His work was especially noted for its compositional directness. He had assisted in the hanging of the show at the Carnegie Institute and thereafter he entered wholeheartedly into the spirit and efforts of the Photo-Secession. The critic Sadakichi Hartmann prophesied that "we cannot help predicting a good future for him" and noted that he "has solved various pictorial problems, which even would set a Stieglitz or a Steichen thinking."

Steichen had kept his promise to Stieglitz that he would never give up photography. During his first stay in Paris this had not been easy. Once he wrote to Stieglitz, "I only wish I could give it more time — even now I am giving it too much. I must stop for a while—and paint hard again." But the famed sculptor Auguste Rodin, whom he had sought out in Paris, liked his photographs and called them great works of art. Then, in 1902, ten of his photographs, submitted as "prints," were accepted by the jury of the Salon des Beaux Arts in Paris. This acceptance of the infant art by such a supreme authority was greeted with wild delight by photographers, but it was short lived, for the jury reversed their decision when they learned these were "photographs." Steichen ruefully wrote to Stieglitz, "oh such a rumpus!" Nevertheless, Steichen continued to work at both photography and painting, especially at portraiture in which he produced the finest work done in photography at that time. He was a "manipulator," working primarily with the gum-bichromate process, but experimenting with other techniques as well. He had returned to the United States in 1903, and with his

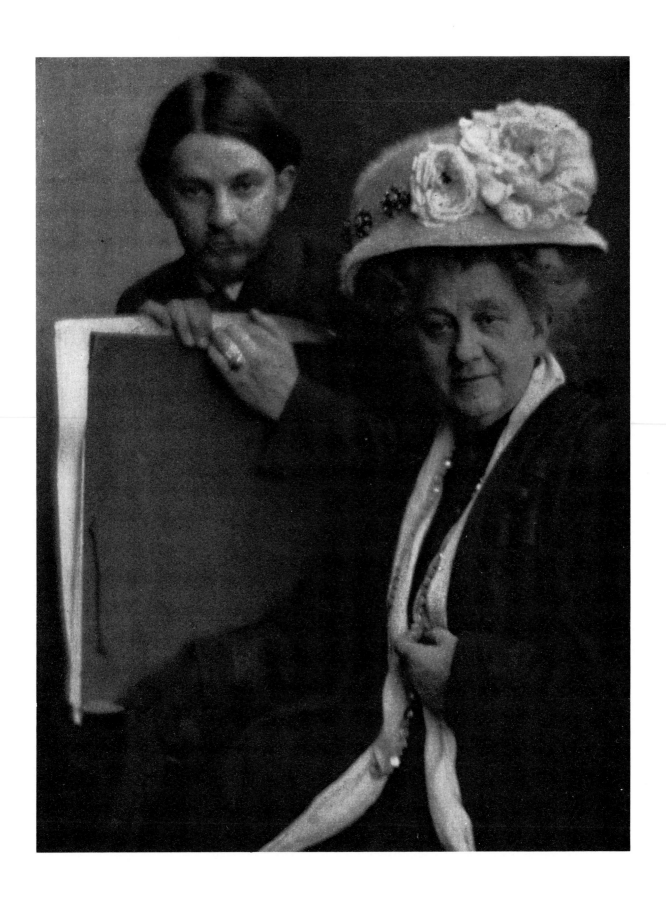

Clarence H. White: *Alvin Langdon Coburn and His Mother* (1909) 35

wife settled down in a garret at 291 Fifth Avenue to paint and to photograph. He was one of the strongest pillars of the Secession, assisting with the hanging of exhibitions as well as contributing his work for the loan shows time and again. It is significant to note that his work, and articles about it, appear in fifteen of the fifty issues of *Camera Work* (easily the greatest representation there of any artist). Of these, the reproductions in three were devoted exclusively to his work. Stieglitz continually delighted in pointing out that great photographs were being made by an artist who preferred to use the medium, even though he could use the palette equally as well.

The ever increasing success of the Secession in exhibitions the world over, prompted Stieglitz to set his sights higher. His proposals met with enthusiastic support from his colleagues, such as Coburn, who wrote: "Bravo!! International Salon! I thought you must have something up your sleeve you were keeping so quiet." Stieglitz had begun to plan a great international exhibition of pictorial photography for New York. At the same time he envisioned forming a governing body for all the national pictorial groups such as the Photo-Secession and the Linked Ring. During 1904, he corresponded with the leaders of the Linked Ring concerning such a scheme. However, he found them extremely reluctant to give up their autonomy to an international body. Although a draft was drawn up, it was either never approved by the members of the Linked Ring or never went into effect. In the October, 1904, issue of *Camera Work* he coyly announced that "the squally appearance of the photographic sea is more apparent than real, for the recognized leaders and their friends throughout the world are working in entire harmony toward an end which in our next number we hope to make public." The announcement never came. Instead, the first serious effort to challenge the Photo-Secession appeared.

It is said that imitation is the best form of flattery. By July, 1904, two organizations who liked to think of themselves as "Knights of the Lens" had been organized. One was called "'The Elect,' a Postal Camera Club," and the other was known as "The Salon Club." Both sought to emulate the aesthetic criteria of the Secession, but the leaders of both lacked the judgment and unerring taste of Stieglitz. Moreover they sought to base their efforts on popular appeal, and to establish this fact the Salon Club proceeded to organize the "American Photographic Salon."

It proved to be an occasion for extremely bitter charges and counter-charges on both sides. The Salon Club, led by a number of professional photographers, referred to the Secession as a "little clique of would-be monopolists," to emphasize that the Salon was to be established for the great number of photographers who had no opportunity to show their work. The chairman of the Salon was Curtis Bell, a professional photographer who had just set up a studio in New York. During the summer of 1904, he engaged in some especially bitter diatribes against Stieglitz in the photographic press. Soon, the editorial columns of almost every photographic magazine were airing their opinions. It was one of the most severe tests that the Secession had yet faced, and Stieglitz met it squarely by bluntly asserting that the Secession would have nothing to do with the American Salon. The extent to which this situation involved personalities, now forgotten, is indicated in a letter from Keiley to Stieglitz:

> "...The Hartmann-Bell-Rood situation is most interesting—we have Rood now pitted against Hartmann & Bell—Rubincam & Kerfoot watching Rood-Bell crowd. Then we have Col. Ockerson & Zimmerman & Ackerman slinging mud at each other and after they have all weakened their several positions out comes your letter a strong snappy-convincing thing to clinch matters both as to St. Louis & the N. Y. Salon.—On top of this I have quietly and industriously

circulated the idea that the Bell Salon is nothing more than an attempt to fore-
stall & over set an international exhibition for 1905 — long contemplated by
you..."[18]

Despite all the bickering and ill-feeling the First American Salon took place
during the month of December, 1904. *Camera Work* conscientiously reviewed the
show, and reprinted a number of the reviews from the newspapers. This was the first
instance of a practice that was to continue throughout the life of the magazine and to
make it a unique chronicle of the movement. Although the critics found the work
entered in the Salon to be vastly inferior, there were a few workers of original talent.
One of these was George Seeley. His work was seen at the Salon by Coburn, who con-
tacted him and during the course of the next year brought him into the Secession. His
photographs of draped female figures in shadowy landscapes were deemed to be the
only strong work seen in the Salon, and thereafter they appeared regularly in the
Secession exhibitions.

The Salon Club appeared to have stolen a march. Although the work of the
Secession was hailed abroad and in exhibitions across the United States, and although
Camera Work was strong and vigorous, for the moment, as far as the public was con-
cerned, the Salon Club had the upper hand in New York. For the work of the Secession
photographers had not been exhibited in that city since the exhibition at the National
Arts Club, some three years previously. No opportunity had ever presented itself.
Many of the Secessionists, including Stieglitz and Steichen, had maintained their mem-
berships in the Camera Club, and occasionally had exhibitions of their work there.
But as members of the Secession they had no place to show, because, in accord with
Stieglitz' original concept, they had never established rooms for themselves. They had
formed the pleasant habit of holding dinner meetings, which had proved to be increas-
ingly popular. It was becoming ever more apparent that they should establish a perma-
nent base in New York.

V. THE LITTLE GALLERIES

STEICHEN, like Stieglitz, was disgusted with the turn of current photographic events in New York. On February 25, 1905, a successful show of his paintings was held at the galleries of Eugene Glaenzer and Company in New York. One day he proposed to Stieglitz that they take over the two rooms next door to his own quarters at 291 Fifth Avenue and turn it into a gallery for the Photo-Secession. Stieglitz was reluctant, but Steichen was forceful and enthusiastic, and Stieglitz agreed to sign a lease for the place. Steichen set to work to convert the two rooms into galleries where they could show photographs.

On October 14, 1905, a letter went out to all members of the Photo-Secession:

> The Council of the Photo-Secession had planned to hold in the City of New York, early next spring, an exhibition consisting of the very best that has been accomplished in pictorial photography throughout the world, from the time of Hill, the father of pictorial photography, up to date. Many of the prints had been selected for this purpose, but owing to the impossibility of securing at any price adequate gallery accommodations during the desirable New York season, this exhibition must be deferred.
>
> The Photo-Secession, for the present thus unable to hold the proposed big exhibition, has determined to present in detail some of the work which had already been selected and which would have been embraced therein, and for that purpose has leased rooms at 291 Fifth Avenue, New York City, where will be shown continuous fortnightly exhibitions of from thirty to forty prints each. These small but very select shows will consist not only of American pictures never before publicly shown in any city in this country, but also of Austrian, German, British, French and Belgian photographs as well as such other art productions, other than photographic, as the Council of the Photo-Secession can from time to time secure.
>
> It is planned to make these rooms headquarters for all Secessionists and to open them to the public generally..."[19]

Following a dinner at Mouquin's, the restaurant favored by the artists of New York, the "Little Galleries of the Photo-Secession" were formally opened on November 24, 1905, by the Secessionists and friends. On the walls were one hundred photographs by the members of the Secession. They were displayed in a handsome setting. Steichen had done his work well. As *Camera Work* described it:

> "...One of the larger rooms is kept in dull olive tones, the burlap wall-covering being a warm olive gray; the woodwork and moldings similar in general color, but considerably darker. The hangings are of an olive-sepia sateen, and the ceiling and canopy are of a very deep creamy gray. The small room is designed especially to show prints on very light mounts or in white frames. The walls of this room are covered with a bleached natural burlap; the woodwork and molding are pure white; the hangings, a dull ecru. The third room is decorated in gray-blue, dull salmon, and olive-gray. In all the rooms the lampshades match the wall-coverings."[20]

Following the announced intention of presenting the work that had been planned for the international exhibition, the second group of photographs to be shown at The Little Galleries was an exhibition of French work. Represented were Robert Demachy, Captain Puyo, René Le Bégue, and others, all of whom showed prints made by the gum-bichromate technique, which allowed them to tint their prints and give them a painterly appearance. On February 21, 1906, a British exhibition was

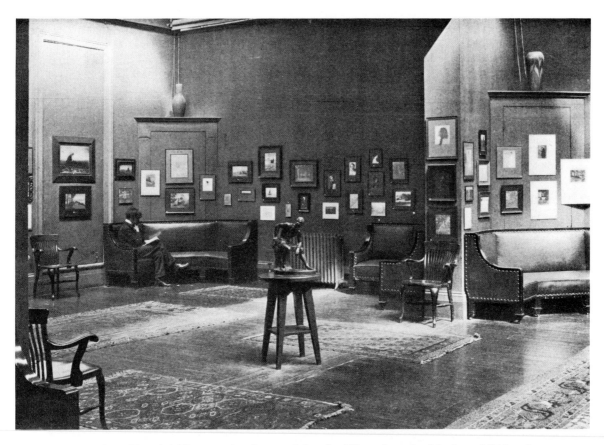

"American Pictorial Photography Arranged by the 'Photo-Secession,'" the exhibition in
the National Arts Club, New York, March 5–22, 1902.

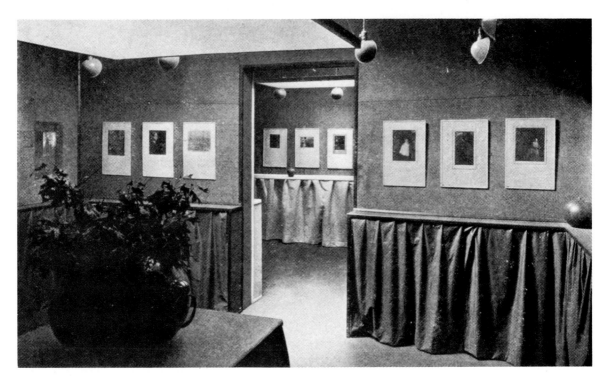

An exhibition of work by Clarence H. White and Gertrude Käsebier in the Little Galleries
of the Photo-Secession, New York, February 5–19, 1906.

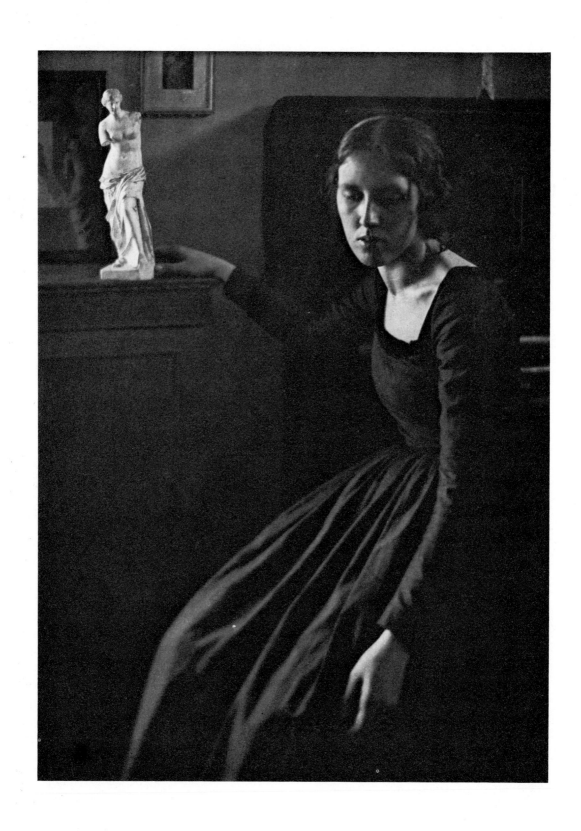

Clarence H. White: *Lady in Black with Statuette* (1898)

opened. It consisted of architectural photographs by Frederick Evans, a representative collection of the work of the Scotch photographer J. Craig Annan, and a selection of photographs by David Octavius Hill. The work of this 19th century pioneer had been restored to public view by Annan, who had delighted in printing a collection of Hill's negatives by photogravure, and which he first exhibited at the Glasgow International Exhibition in 1901. Hill's photographs were hailed by the pictorialists, who soon were emulating them in their portraiture.[21] Closing out the season in April, 1906, was the third exhibition of foreign work, by German and Austrian photographers. Heinrich Kühn, Hugo Henneberg and Hans Watzek, known as the "Trifolium," and the German Hofmeister brothers, carried pictorial landscape photography to a massive expression. They exhibited huge prints, which, utilizing the suppression of detail possible with the gum-bichromate process, sought to depict atmosphere rather than topographical details.

Alternating with these exhibitions of foreign work were shows by members of the Secession. On January 26, 1906, Herbert G. French, an amateur photographer from Cincinnati, Ohio, showed a series of photographs illustrating Tennyson's "Idylls of the King," an exhibition which was reviewed with some interest because photography as illustration of literary subject was still looked upon with disfavor. This exhibition was followed by one of the work of Gertrude Käsebier and Clarence White. The last one-man show of the season was that of Eduard Steichen, held from March 9 to March 24, 1906. With the fine touch of showmanship and calculated purpose which was to be so important in all Photo-Secession exhibitions, it was planned to coincide with an exhibition of his paintings at the Glaenzer Galleries. *Camera Work* noted that, "This juxtaposition of mediums was of itself an interesting event, and the fact that the selling-power of the photographs reached the brilliant success of the paintings is another milestone passed upon the road to appreciative recognition of photography by art-collectors and connoisseurs."

In accord with the idea of showing "art productions, other than photographic," plans had been made to hold a "Salon des Refusés." Taking a cue from the now famous exhibitions of the Impressionist paintings in France, the Secessionists planned to exhibit paintings which had been refused acceptance by the National Academy of Design and other conservative art institutions. But if they expected to find in American painting revolutionary new concepts to match their own in photography, they were indeed doomed to disappointment. Realism was still the dominant preoccupation. Winslow Homer was winning accolades for his seascapes, Impressionism had easily been accepted for its emphasis on the natural scene, and above all the favorite theme, sentiment. The most superficial aspects of life were constantly extolled on canvas. Subjects ran the gamut from gaiety and frivolity to sorrow and anger, but always portrayed in a manner that suggested a life of means and wealth. This work sold and won favor with the juries of the painting competitions. There was as yet no opposition to it. The "Salon des Refusés" was never held, for as Eduard Steichen reflected recently, "There was nothing good being refused."

It was a triumphant first season for the new gallery. Not only public, but also academic recognition was bestowed upon the Photo-Secession. From April 30, to May 27, 1906, the Pennsylvania Academy of the Fine Arts held an "Exhibition of Photographs Arranged by the Photo-Secession." The catalogue of the exhibition stated that the photographs were chosen from the exhibitions held at the galleries of the Photo-Secession and that the Secession had made and hung their own selection. Joseph Keiley reviewed the pictorial movement in an extensive article for *Camera Work* and

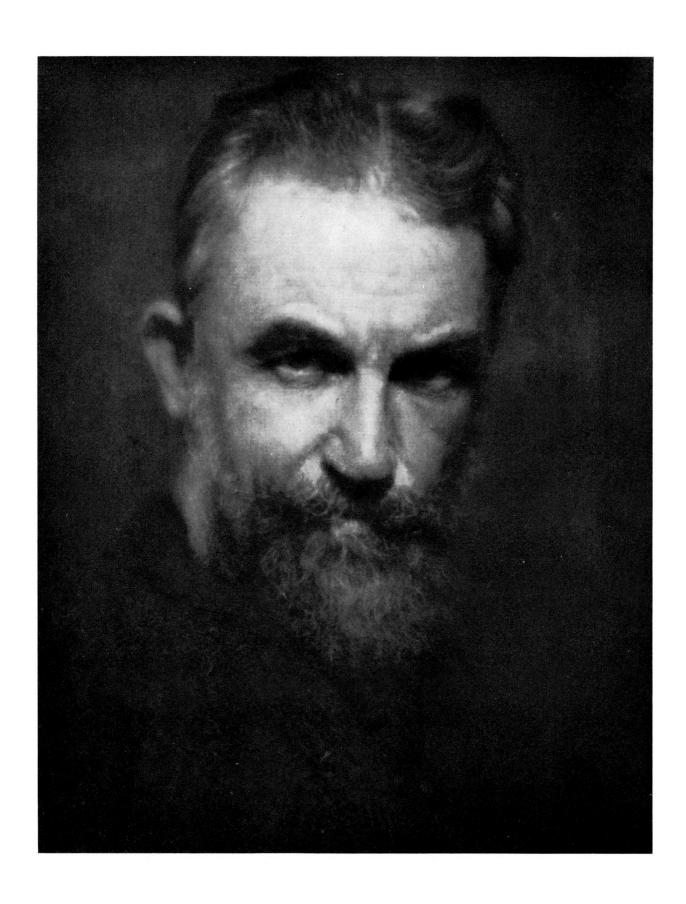

Alvin Langdon Coburn: *Bernard Shaw* (c. 1906)

triumphantly concluded:

"... Today in America the real battle for the recognition of pictorial photography is over. The chief purpose for which the Photo-Secession was established has been accomplished — the serious recognition of photography as an additional medium of pictorial expression."[22]

But Stieglitz pushed on. In September, 1906, following a summer in Europe, he held a press preview of an exhibition of color photographs in the Lumière Autochrome Process, made by Steichen, Eugene and himself. This was the first time that the process had been demonstrated in America. It was a prelude to the opening of the season which came on November 10, with an Exhibition of Members' Work. Eighty-three prints were shown, by the noted as well as the unknowns of the Secession. The work of bringing this show together, as it did in almost all the exhibitions at the Little Galleries, fell on the shoulders of Stieglitz. He accepted it as his duty and responsibility. In November he wrote to his friend Heinrich Kühn:

"Ceaseless activity from early until late in order to finish, even halfway, the work that I have burdened myself with . . . Last year's exhibitions together with the effect of Camera Work year after year, have greatly influenced an enormous number of people — and so I stay in the exhibition rooms every day from ten in the morning to six in the evening just to receive the visitors. That is a horrid torment and task and yet it must be, since so many really interesting people among the visitors require explanations — and then you should really hear how A. S. often holds forth not only on photography but on art and social conditions in America. It is surely not in vain — that I know and feel..."[23]

One of those "really interesting people" who came to the Little Galleries in 1906, was named Pamela Coleman Smith. She was an American, who had been living and working in London, where she did illustrations, and for a short time, published a paper called *The Green Sheaf.* She had not met with much success in America, until she came to Stieglitz. He asked her if she had ever had an exhibition. "No," she had replied, "they said they are afraid." Stieglitz, who had been deeply moved by her wash drawings, particularly one entitled "Death in the House," found the challenge, and her honesty, irresistible. The exhibition of her work opened on January 5, 1907. At first, the response was discouraging. But the prominent critic of the *New York Sun,* James Huneker, was attracted to her work and praised it in his paper as the "workings of a strangely-organized imagination." With the resulting sudden increase in interest, the exhibition had to be prolonged for eight days and a number of works were sold. This was quite contrary to Stieglitz' policies for he never made any effort to sell the works on exhibition and sometimes even preferred not to! The gallery was a place for the affirmation of his beliefs on life and art, not a commercial enterprise.

Following the Pamela Coleman Smith Exhibition photographs again occupied the walls of the Little Gallery. There followed in succession, an exhibition of the work of Baron De Meyer and that of George Seeley, then photographs by Alice Boughton, William B. Dyer, C. Yarnall Abbott, and finally, to conclude the season, the work of Alvin Langdon Coburn.

In January, Coburn, the youngest member of the group, had written to Stieglitz: "I was so glad to get your letter for as you know I greatly appreciate your frank criticism of my work which has always been so helpful to me. I only wish that I might see the exhibition on the walls for after all that is the great test and the lesson that the 'Little Galleries' has been to all of us...I am working hard on a lot of new things in black and white and colour, which I always make with the idea in the back of my

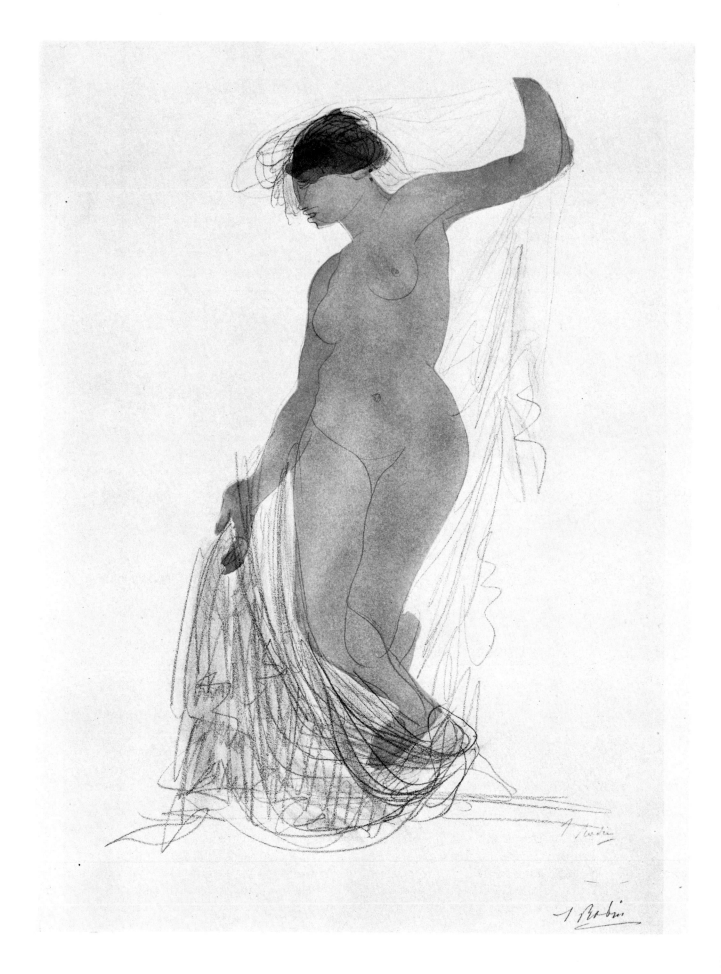

Auguste Rodin: *Drawing* (c. 1911)

head what will A. S. think of it? It keeps me up to the mark I can tell you . . ." He was not the only one who had benefited from Stieglitz' counsel. Many others in the group found themselves turning to him for advice on when to exhibit, for criticism of their work, or for encouragement. Even such far-distant members as Myra Wiggins in Salem, Oregon, wrote to him about her photographs, gratefully remarking that he was ". . . a sort of Father Confessor to all your following."

The season of 1907 opened on November 18, with the exhibition of members' work, the attraction of which was a display of Autochrome color transparencies by Stieglitz, Steichen, Eugene, and White. It was a successful exhibition, judged by the attendance figures, but the next exhibition was to be even more successful.

Eduard Steichen, before returning to Europe in the spring of 1906, had discussed with Stieglitz the possibility of sending back some of the work then being done in Europe. He knew Rodin well, and was confident of obtaining some examples of his graphic work. The announcement of the Pamela Coleman Smith exhibition came as a complete surprise to him. Quickly he wrote a cable to Stieglitz, "Do you still want exhibition of Rodin drawings?" (However, he thriftily deleted the word "still" when the cable was sent).[24] Stieglitz quickly sent back, "Yes." Thus, the first exhibition of Rodin drawings, rapid sketches of the female form, opened at the Little Galleries on January 2, 1908. Press reviews were generally favorable, although one rather pessimistically stated, "An exhibition of very great importance to artists and sculptors, though doubtless it will be pretty nearly incomprehensible to the general public." Though this was true, Camera Work proudly stated that an "unusual assemblage" had given it a "truer and more spontaneous appreciation." There were a number of critics, however, who didn't care for the "preciosity" of the work, and it was obvious that the Photo-Secession was engaging in a new battle.

The difficult job of following this extraordinary exhibition was well handled by George Seeley, who opened an exhibition of his photographs on February 7, 1908. This was followed by an exhibition of drawings by Pamela Coleman Smith, etchings and bookplates by Willi Geiger, and etchings by B. S. McLaughlin. These exhibitions received the attentions of the press, such as Arthur Hoeber's comments in the New York *Globe and Commercial Advertiser:* "Just what can be done by holding fast to an ideal is exemplified in the record, short but honorable, of the Photo-Secession Galleries on Fifth Avenue . . . For profit? Never! There has been no return, nothing of a commercial nature in any way, shape, or manner. It is all a foolish ideal. A place where really good artistic work — primarily photographs — may be seen. But it is not by any means limited to photography . . ." Not all critics were so friendly, however, and their chance to prove it was coming soon.

In Paris, Steichen, like a number of other young American artists, was being exposed to a new style of painting that introduced a bold, imaginative use of color. When it first burst upon the French public in 1905, it was greeted with howls of derision. One critic christened the painters "Les Fauves," the wild beasts. Although the public refused to accept these paintings, many of the young artists found them a revelation. Steichen had met Henri Matisse, the acknowledged leader of the Fauves, and had been much affected by his extraordinary innovations. When the time came in January of 1908, to return to the United States to hang a show of his photographs at the Little Galleries, Steichen wrote to Stieglitz, "The Matisses I'll bring along — I'll explain all about that stuff and my plans about it when I get there — and I would not show any of the things even to the fellows at the Secession — till we get them up . . ." Thus the first Matisse exhibition in the United States and the first one-man

exhibition of Matisse outside Paris, opened at the Little Galleries of the Photo-Secession on April 6, 1908, and continued through April 26. The show was comprised of drawings, lithographs, water colors and etchings, mostly studies of the figure. *Camera Work* impishly described the exhibition as an "irritant" and "a timely one." The critics, completely unprepared for such shock tactics, were hesitant, but able. J. E. Chamberlain wrote for the *New York Evening Mail,* "They show Matisse, whose idea is that you should in painting get as far away from nature as possible. If nature is to be followed, why, let the camera do that. The artist should paint only abstractions, gigantic symbols, ideas in broad lines, splotches of color that suggest the thoughts that broke through language and escaped, and all that..." Although they almost all admired his handling of line, still, his unabashed rendering of the female figure was considered a blow to the stringent moralities of American art. The exhibition was a major victory for the "cause" at the Little Galleries.

Nor was this the only reason for celebration within the ranks of the Photo-Secession. During January, they exhibited, for the first and only time, with a group of painters whose spirit and effect on their own art was much akin to that of the Secession. These painters were known by a name sarcastically applied to their work: "The Ash Can School." Others preferred to call them "The Eight." They had won this name when, eight in number, they banded together for mutual support, and held a show at the Macbeth Gallery in 1908. Their work was refused by the National Academy of Design because of its supposedly banal subject matter. For these painters delighted in showing the turmoil and life of the city. Their world was dirty winter streets, the elevated trains at rush hour, the city parks. Their people were those who existed within the turmoil of the city and the squalor of its tenements. Because these painters defied convention to portray the reality of twentieth century America they found their work unwanted, scorned. But they did find champions in the dealer William Macbeth and the critic James Huneker. In the columns of the *New York Sun,* Huneker defended the new spirit. In January, 1908, the work of "The Eight" was shown at the National Arts Club, as part of the "Special Exhibition of Contemporary Art."

Besides the "Rebellious Eight," the exhibition included paintings by such well known artists of the times as the Dabo brothers, William M. Chase, Childe Hassam and Rockwell Kent. A reporter for the *New York Times* noted with admiration that the "virile" work of "The Eight" was shown along with the more poetic manifestations of the accepted artists and pointed out that:

> "...to those who have no axe to grind, who are not special pleaders for this or
> that man or clique, and who, therefore, are content to accept the expression of
> the spirit of modern times, in whatever guise it comes, so long as it remains per-
> sonal, these canvases will carry a message that cannot be lightly turned away
> with a disdainful curl of the lip ... A feature of the exhibition is the showing
> of photographs by the members of the Photo-Secession on the same plane as
> paintings, which has never before been done in this country. That they are
> deserving of this recognition is amply proved by the manner in which these
> prints hold their own with the paintings and etchings shown."[25]

As early as 1892, Stieglitz had begun to make photographs in the streets of New York with a hand camera. He had just returned to America from his many years as a student in Berlin, with its old world charms. He loathed the raw, commercial world of America, but found in the life exposed to him on the streets and avenues of New York, a special kind of beauty. Other members of the Photo-Secession followed his example.

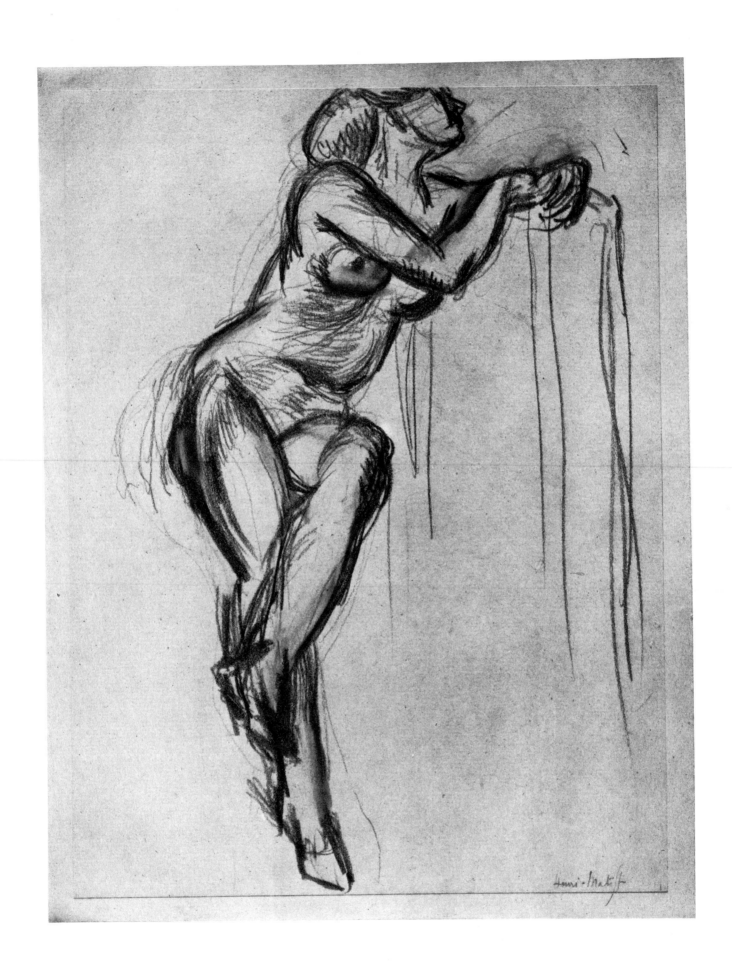

Henri Matisse: *Photogravure of Drawing* (c. 1907)

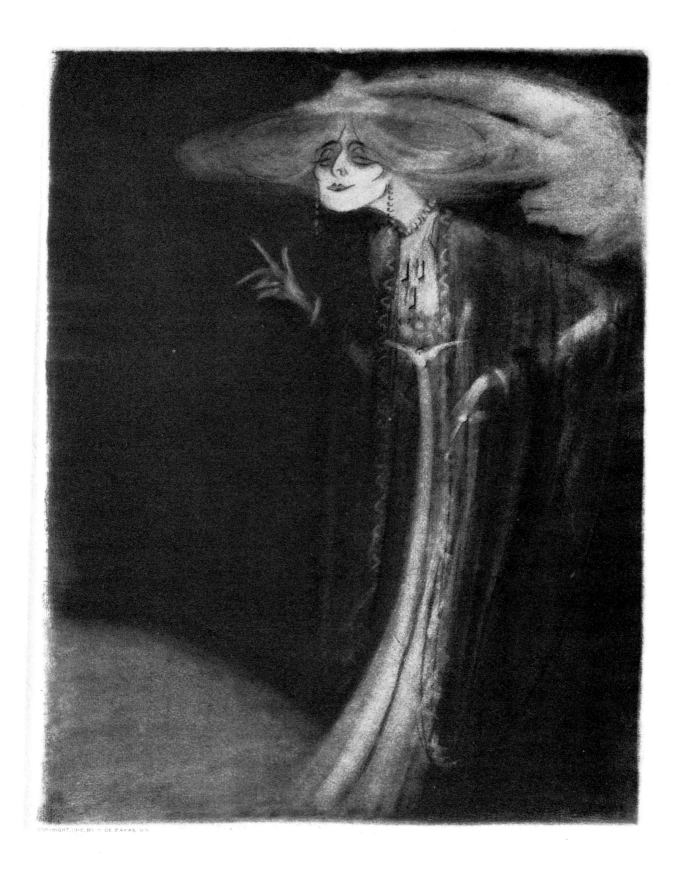

Mariuș De Zayas: *Mrs. Brown Potter* (c. 1910)

Their photographs of buildings, streets, the special beauty of city shapes and moods, were shown beside paintings by "the Eight" and other contemporary artists. Their work and their medium reflected a new spirit of the times, and as such, equalled the established arts.

But such triumphs were won only at the expense of bitterness and jealousies. Headlines on the front page of the *New York Times* on the morning of February 14, 1908, proclaimed: "CAMERA CLUB OUSTS ALFRED STIEGLITZ." He had been asked to resign from the club, but upon inquiring of the charges found that the officers were unwilling to state any specific reason. There ensued a bitter quarrel, and the Camera Club was soon split into factions, for and against Stieglitz. Eventually the officers of the club, apparently motivated by sheer jealousy, were forced to retract their charge. But it was too late. Almost forty members resigned in a gesture of loyalty to Stieglitz.

With such antagonism it took courage to go on with photography, but the season opened as was the custom with the exhibition of members' work. However it opened in new quarters. In the Spring of 1908, Stieglitz was suddenly faced with a demand from the landlord for double the rent. It was much more than the small income that came from the dues of paying members. Stieglitz himself had already used his own funds to support the gallery and *Camera Work*. But to many the Little Galleries were becoming a strong spiritual force in their lives and with financial aid from Paul B. Haviland, a lawyer, and other friends, two rooms were taken directly across the hall from the old gallery.

Following the exhibition of members' work, caricatures by the Spanish artist Marius de Zayas were shown along with Autochromes by J. Nilsen Laurvik, who later became a writer and art critic. There then followed in succession one-man shows of Alvin Langdon Coburn and Baron De Meyer. The only other photographic exhibition of the year was by Steichen, who showed a series he had taken of Rodin's Balzac in the sculptor's garden, by moonlight.

Etchings, dry point, and bookplates by Allen Lewis, an American, were shown in an exhibition which opened on Feb. 6, 1909, followed by another exhibition of drawings by Pamela Coleman Smith. Meanwhile Steichen was now actively searching for new creative work in Paris. It was not hard to find, for Paris at that time was the goal of every aspiring artist and there modern art was slowly but surely evolving on canvas and paper. It was no boast when Steichen could write to Stieglitz, "I wonder what your plans are for this winter I have any amount of material available." This material he had seen in the studios of his artist friends in Paris. There were many young Americans there at this time; they had even joined together to form an association, "The New Society of American Artists in Paris." Among them were John Marin and Alfred Maurer. Their work had a strong appeal to Steichen, and he announced to Stieglitz:

> "I have just had some stuff packed and shipped to Of![26] for the Secession gallery — there are 24 water colors by John Marin, 15 small oil sketches by Alfred Maurer. The Marin water colors are about as good as anything in that line that has ever been done . . . The Mauer's [sic] are certainly howlers as *color* and ought to make the people that kicked at Matisse feel ashamed of themselves — I hope that these things will be appreciated — as they represent with two other fellows the best American things I know over here. Both men have something keener and healthier to say than the regular studio "Jargon" afloat in New York shows . . ."[27]

The pictures Steichen shipped were shown at the Little Galleries. Although these

two artists were to make important contributions to twentieth century American art, their first exhibition was not a critical success. Alfred Maurer, previously a student of the academician William M. Chase, had spent several years in Paris, gradually coming under the spell of impressionism and the Fauves. In his studio, Steichen had found a number of small sketches done in oil on boards in a loose impressionist style. From John Marin's work, he chose water color sketches, fresh new scenes of city and landscape. The critics were somewhat taken aback. James Huneker, for the readers of the New York *Sun,* damned Maurer with faint praise, stating that "it is a cruel Eastern garden of writhing arabesques that he puts before us" but relenting to add, "this chap has talent as well as boldness." Marin's work was favored, for Huneker found "there is the poet in this young man" and described his work as "subtly evocative." It was the beginning of a lifelong friendship for Stieglitz and Marin. There sprang up an understanding between them which was to grow and enrich the lives of each. Stieglitz exhibited Marin's work every year thereafter until the gallery closed in 1917, and continued to do so later in his other galleries.

So it was with Marsden Hartley, who was introduced to Stieglitz by a poet named Shamus O'Sheele. Stieglitz found in his work the feeling of "fresh air and freedom," and in the man, modesty and pride. He gave him an exhibition in May, 1909, and was to do so many times thereafter throughout the twenties and thirties. Although working predominantly with landscape, Hartley had broken with all American traditions and adopted an impressionist technique based on form and color. An article in *Camera Work* spoke of the "strictly physical sensation" of his work, and went on to define the relationship of photography and the other graphic arts in the exhibitions at the Little Gallery:

"...photography in order to assert its esthetic possibilities strenuously strove to become 'pictorial'; and this endeavor produced in recent years the singular coincidence that, while men of the lens busied themselves with endowing their new and most pliable medium with the beauties of former art expressions, those of the brush were seeking but for the accuracy of the camera plus a technique that was novel and — unphotographic."[28]

VI. THE DRESDEN AND BUFFALO EXHIBITIONS

THERE was still much work to be done in pictorial photography. In February, 1909, the National Arts Club of New York again opened its doors and held an "International Exhibition of Pictorial Photography." At the same time Stieglitz was faced with the tremendous task of assembling an exhibition of American work to send to a huge photographic exposition which was to take place in Dresden from May to October of 1909. It meant hours of work, cajoling photographers to prepare and send prints. When they refused, or reneged their promises, Stieglitz sent examples of their work from his own collection. It was an arduous and thankless task. Steichen helped, writing letters to remind photographers that, "...We have all arrived to the important stage we are at by our united effort not that I depreciate the value of individual effort — that I take for granted — but great things can only be accomplished by our united solidarity." The result of their labors, and those of the organizers, was the most comprehensive exposition of photography to that time, for it covered the scientific and commercial applications, as well as the artistic. But there was something lacking. W. I. Lincoln Adams, editor of *The Photographic Times* remarked that the Secessionists and other pictorial photographers, "appear to be doing nothing new." Charles Caffin, who had championed their cause for many years, found:

> "...a graver charge of inadequacy, based upon a failure in respect to the qualities of photography that are fundamentally photographic. Need I repeat that these are the product of the essentially scientific nature of the process, and of the precision of the photographic record? It is an arbitrary interference with the latter and an ignorance of the former, which are responsible for so much that is tediously commonplace in ordinary commercial photography and so solemnly inefficient in the work of the ambitious 'pictorialist,' It was this that the Dresden Exposition so impressively emphasized..."[29]

In London, also, pictorial photography was beset with grave charges. The Linked Ring, which had led the battle for the recognition of pictorial photography was split with factions. The members of the Photo-Secession had, for a number of years, contributed work to the London Salon in ever increasing numbers. But trouble with customs, new opportunities for showing in the United States, and a generally hostile press in England, had caused the number of American entries to fall, and finally, in 1907, almost all the American members resigned from the Linked Ring. To bolster their sagging standards, the Selecting Committee of the London Salon held an extra-select show of the work of only eight photographers. It was so poorly received that the next year the committee attempted just the opposite. The outcome of that exhibition proved that no one was satisfied. There was no strong leadership in the Linked Ring, and what leaders there were continually fought among themselves. Their jury system was actually suppressing any original efforts, for photographers refused to submit any work expressing new ideas, thinking it would not pass the jury. Once again appeals for help went out to Stieglitz in America, and once again he took a stand. Writing to George Davison, one of the oldest members of the Linked Ring, on April 10, 1909, he foretold the end:

> "...The Ring as a body has been diametrically opposed to the higher ideals it is supposed to stand for & when last year it practically repudiated its own Committee's work it made it impossible for me at least to continue feeling any sympathy for it ... The work that is going on in the Secession is growing daily, one might say. 291 Fifth Avenue is not only headquarters for American photog-

raphy but it has actually become a big moral force in the world of painting. The work begun 26 years ago by me is about to be finished. This is no exaggeration, it is all literally true. For that very reason we can't be identified with anything which we ourselves do not believe in. Our strength has been that we have had faith in our work & that we have had a definite goal..."[30]

But if the Linked Ring was dying, the Little Gallery, or as it was more familiarly known by now, "291," was growing in importance in the field of photography and the other arts. The last show during the Spring had been of Japanese prints from the F. W. Hunter collection. During the summer Stieglitz made one of his many trips to Europe, where he visited the Dresden Exposition, spent time in Paris with Steichen, discovered the new art for himself, and met John Marin for the first time. Back in New York, he opened "291" with two demonstrations of an awakening social conscience in both American and European art. On November 24, the season of 1909-1910, began with an exhibition of monotypes and drawings by Eugene Higgins, an American who, working in the spirit of the Eight, chose to portray the human wreckage of the streets. This grim display of poverty was followed by an intimate tour of French brothels, as seen by Henri de Toulouse-Lautrec, just coming into repute in Europe but never before shown in the United States. These prints, which Stieglitz had collected and purchased while in Munich, were shown as a slap at the overtly commercial artists in America who took as their model the popular illustrator Charles Dana Gibson. Following this exhibition, recent color photographs by Eduard Steichen were shown. Next, on February 7, 1910, came a Marin exhibition. The critics were bewildered as ever, and were inclined to refer to him as under the influence of Matisse. This categorical reference on the part of the critics to all modern painters needed some correcting, so Stieglitz applied a lesson. The next exhibition became the second of Matisse's work. Drawings and reproductions of his paintings were shown. Again it was incomprehensible to the critics, and although they respected Stieglitz and the work he was doing, they stuck to their opinions, which were not favorable. Having established a basis for comparison, Stieglitz pushed on with relentless intent, and as the Matisse came down, an exhibition of the work of those American painters who were supposed to be his disciples went up. This exhibition, entitled "Younger American Painters" contained the work of Eduard Steichen, G. Putnam Brinley, Arthur B. Carles, Arthur G. Dove, Laurence Fellows, Marsden Hartley, John Marin, Alfred Maurer, and Max Weber. Stieglitz stoutly maintained that each man was "working along individual lines toward the realization of a new artistic ideal," rather than being simply "Matissites." The critics were not so sure and spoke mainly of their color technique. This strategy in exhibitions was a change from the original plans of a number of one-man exhibitions of these American artists working in Paris. That it was planned and executed in the final manner was a testimonial to Stieglitz' virtuosity and to the fact that he attempted to demonstrate the vitality of art, not its commercial value. In this same fashion, there followed a second exhibition of Rodin's sketches to give a more comprehensive view of his work, and then a burst of laughter as the season ended with an exhibition of caricatures by Marius de Zayas.

A little humor was a good thing. The constant hammering at the reactionary art world of America was a nearly impossible job. Stieglitz was the only man in New York who heeded the activity in Paris. True, there was the Havemeyer Collection, formed under the guidance of the American impressionist painter Mary Cassatt, but it was made up of impressionist works that were now quite acceptable. When the philanthropist Hugo Reisinger organized an exhibition of American art to be shown

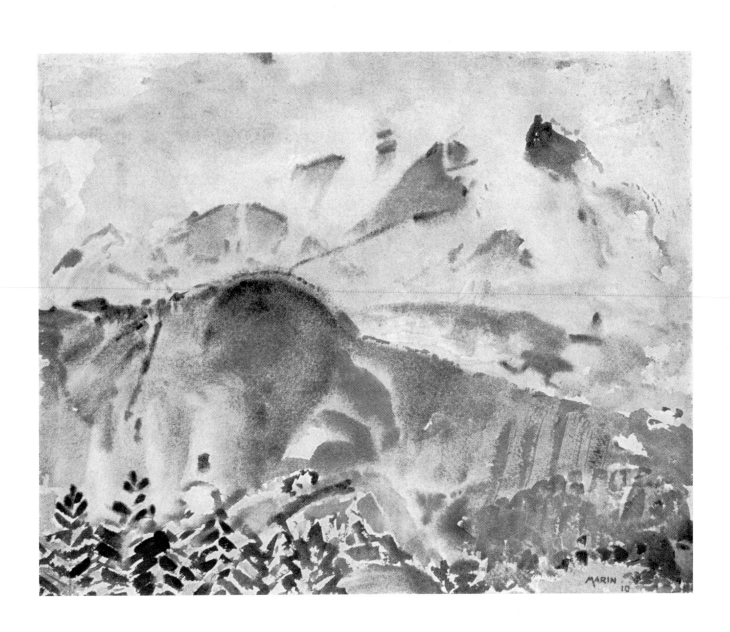

John Marin: *In the Tirol—No. 23* (1910)

in Germany, he included the reviled "Ash Can School," but that was as far as he dared to go. Reviewing the exhibition for *The Craftsman,* Christian Brinton wrote:

> "...Mr. Reisinger paused, however, ... before those more advanced tendencies which in Germany are represented by the leading spirits of the Berlin Secession, and on this side by those brilliant experimentalists who, under the protecting aegis of Mr. Alfred Stieglitz, are now creating such turmoil in the breasts of the timid..."[31]

Unfortunately the timid in America also occupied the positions of authority as far as the museums and what went into them were concerned. Under the guidance of such dealers as Joseph Duveen, the Frick, Gardner, Widener, and Morgan collections were being assembled with treasures from the heritage of the great centuries of renaissance and medieval art. J. P. Morgan had aided in the development of New York's august Metropolitan Museum of Art, and consequently retained the power to dictate its acquisition policy. Forced to conform to his conservative policies it became a museum of crafts. Although an exhibition of Impressionist paintings was held at the Metropolitan in 1906, this was an exception. Most of the directors who had been selected by Morgan were unable to comprehend the revolution that was taking place in the world of European art. For example, Sir Casper Purdon Clarke was forced to admit in an interview for the *New York Evening Post,* in 1909:

> "...There is a state of unrest all over the world in art as in other things. It is the same in literature as in music, in painting, and in sculpture. And I dislike unrest..."[32]

There was unrest in photography as well. Many of the photographic journals were asking "what is wrong with the Photo-Secession?" It appeared that the quality of the illustrations in *Camera Work* was falling off, and the Secession no longer participated in exhibitions. But the members were still active in photography and to them the predominance of art media other than photography at "291" was incomprehensible. Robert Demachy wrote to Secessionist Elizabeth Buehrmann, ". . . I should have liked to show my transfer work in America but Stieglitz is so taken up with mad futurists that he will have none of it . . ." Paul Haviland attempted to calm their fears in a statement for *Camera Work:*

> "The season, which ended with but a single photographic exhibition, has led many of our friends to presume that the Photo-Secession was losing its interest in photography and that "The Bunch at 291" was steering the association away from its original purpose. The best answer is to be found in the pages of *Camera Work* — the official organ of the Photo-Secession — in which the best examples of photography are presented regularly to its subscribers . . . If the position of photography among the arts is to be firmly and permanently established, this can be accomplished by proving it capable of standing the test of comparison with the best work in other media and not by isolating it . . . This is the help the exhibitions of the Photo-Secession are giving to photographers."[33]

But the end was in sight. Stieglitz was planning a finale. The means was to be an exhibition at the Albright Art Gallery in Buffalo, New York. It had been planned during 1909, with the cooperation of that gallery's director, Charles M. Kurtz. He had been on the jury which selected the photographs for the St. Louis Exposition in 1904, and, following that introduction to pictorial photography, had invited a local group of amateur photographers, The Photo-Pictorialists of Buffalo, to exhibit their work at the Albright Gallery in an exhibition held in September, 1908. Encouraged by the reception accorded this exhibition, he began to plan an international exhibition of

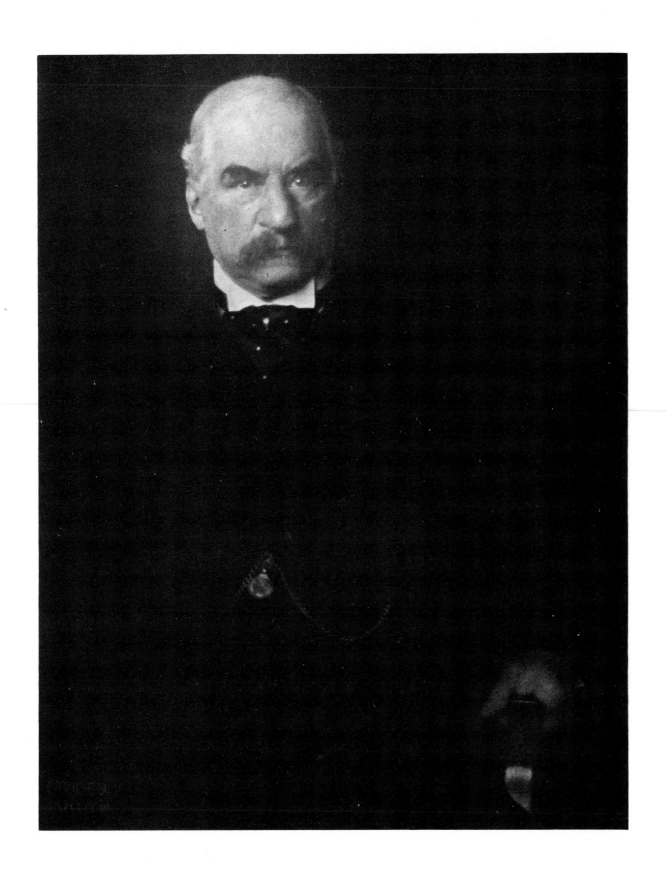

Eduard J. Steichen: *J. Pierpont Morgan, Esq.* (1903) 55

photography to take place at the Albright Art Gallery in 1909. To arrange this exhibition he called upon The Photo-Pictorialists of Buffalo and the Photo-Secession. But Stieglitz felt that the Albright Gallery itself should do the exhibition since the lower standards of the other groups would prevent it from actually being a significant demonstration of photography as a fine art. Then, early in 1909, Kurtz died.

The exhibition seemed to be forgotten, but Coburn, stopping in Buffalo to see the Acting Director of the Gallery, Cornelia B. Sage, found her very much interested and suggested that she contact Stieglitz. On October 5, 1909, she wrote to Stieglitz proposing that the Photo-Secession alone prepare and hold an exhibition in Buffalo during the following year. Stieglitz agreed, and by March 15, 1910, with the approval of Miss Sage, had planned an exhibition which was to include the Photo-Pictorialists of Buffalo, as well as the Photo-Secession, and, at Stieglitz' insistence, an open section. Along with the full-time job of running "291," Stieglitz was again burdened with the details of preparing a major exhibition. He lost no time, writing to Secessionists such as George Seeley: "Get Busy . . . The reputation, not only of the Photo-Secession, but of photography is at stake and I intend to muster all the forces available to win out for us." The announcement sent out by the gallery reflected Miss Sage's complete trust in Stieglitz, for it stated, "To ensure the best possible representation, the arrangements have been placed in the hands of that organization which has done the most to promote this particular branch of art — The Photo-Secession." But the other groups in amateur photography did not share this enthusiasm, and once again the photographic journals leveled bitter criticism at the Photo-Secession. The editor of *American Photography,* Frank R. Fraprie, referred to it as "a reactionary force of the most dangerous type." The Photo-Pictorialists of Buffalo flatly refused to have anything to do with the exhibition. A number of photographers and photographic societies tried to bring pressure to bear on the Gallery to have the exhibition organized entirely on an open, competitive basis. In spite of all opposition Stieglitz triumphed.

The exhibition opened on November 4, 1910 and ran through December 1. The foreword of the exhibition catalogue stated conclusively that "The aim of this exhibition is to sum up the development and progress of photography as a means of pictorial expression . . ." The exhibition contained the work of all the Secessionists, the well-known foreign workers, an open section, and a series of prints by D. O. Hill as an historical note. Eight of the museum's galleries were given over to the exhibition. It was hung by Paul Haviland, Clarence White, Alfred Stieglitz and Max Weber. To hang photographs in a structure of classical architecture, designed for large canvases, was not an easy assignment. A successful installation was designed by Weber, a young American painter who had been introduced to "291" by Steichen. He recalled recently, ". . . I treated the geometric rectangles and features of the prints as windows in the walls of a building, and gave special attention to values of dark and light and tone to add to the decorative effect of an entire wall or entire gallery."

The Buffalo press gave the exhibition extensive coverage and generally commended the Albright Gallery for having brought it to Buffalo. In order to perpetuate it, the gallery purchased thirteen prints from the exhibition and made plans to establish a special room for photography. The attendance figures were the greatest in the history of the gallery. Stieglitz felt the satisfaction of a job well done, and the sadness of a man who realized that it meant the end of a great part of his life. He wrote to his colleague George Seeley, ". . . The show seems like a dream to me. Even Mrs. Stieglitz who saw it finally realizes that something *has happened* — it all was a revelation to her!! Yes, it does mean one gigantic sacrifice, but everything lasting probably means

that. Life-blood is the price." Even the hostile magazine *American Photography* was forced to acknowledge the significance of the exhibition, and its correspondent mused:

"...Is the Photo-Secession, having at last stormed the citadel which it has been assaulting so long, having won that Recognition which has been the watchword of its fight, now singing, in this exhibition, its Nunc dimittis?"[34]

Although a notice for dues was sent out to the members for the year 1911, it was nonetheless the end of the Photo-Secession. Many of the members turned to professional photography as a livelihood, and drifted away from the Secession. The ranks thinned, even though a few new members were admitted in the last years. The group effort, which had kept them working, nourished their art, had perished. The sense of purpose, summarized by Joseph Keiley, was lost:

"If there is that in nature that awakens a quick, throbbing response and an irresistible desire to give definite expression to the thrill of joy thus stirred, seek to express as nearly as possible as you feel, and see, and understand, and not in the terms and mannerisms of recognized classicism of the established masters. This is the lesson that Secessionism would teach..."[35]

The Photo-Secession established the right for photography to be considered a fine art. Through their photographs, and the presentation of them in scores of exhibitions, the Secessionists conclusively demonstrated that it was necessary to differentiate between the photograph as visual reporting and the photograph as visual expression. Subject matter itself did not make photography an art; used with aesthetic understanding, it could be an expressive medium. Despite the painterly techniques favored by the Secessionists, their work at its best is beautiful.

They had won the coveted recognition they sought from academic institutions, but at a price. The techniques they had used, in an effort to draw away from what was rightly their heritage, the mechanical and scientific properties of the medium, were not unlike those industrial processes of the same period which sought to make cast-iron or machine carved wood appear hand-made. Their preoccupation with emulating the surface textures of brush techniques and pigments, the use of soft focus and manipulation of prints, held back their realization of a broader view of photography as an art, based on respect for the characteristics expressed by the photographic process itself. When the Photo-Secession dissolved, some of the members attempted to continue its traditions, and even formed new groups, such as the "Pictorial Photographers of America." The original impetus was lost: "pictorial photography" became synonymous with a vapid, stilted and worn-out style. But a few members began to reappraise a basic concept; the appreciation of photography as an independent medium, unrelated in appearance to painting, and based on its own aesthetic.

In the Albright exhibition, Stieglitz showed a series of photographs made in the streets and harbor of New York. They were unmanipulated prints, honest, straightforward manifestations of the photographic process. In his search for the expression of truth, Stieglitz steadfastly worked with pure photography, accepting the chemical and mechanical properties of the medium for its own special properties. He no longer approved of the painterly techniques which had been the basis of so much Secession photography, and could no longer support those who continued to practice it. The organization which he had founded, and the style which had been established, came to an end.

VII. THE NEW ART

THE effect of the Photo-Secession was apparent in Stieglitz himself. In the Secession he had fought and won, proving himself, to himself as well as to others. Late in December, 1911, he wrote to Sadakichi Hartmann:

"... Since you left a year ago I have undoubtedly had the most remarkable year in my career. Beginning with the Albright Art Gallery show it has been one crescendo culminating with a most remarkable three weeks spent in Paris. There I have had long most interesting [sic] with or at Picasso, Matisse, Rodin, Gordon Craig, Vollard, Bernheim's, Pellerin's; finally winding it up with two days at the Louvre which in reality I *saw* for the first time ... In short my experiences were most unusual and I think they come at the psychological moment. Paris made me realize what the seven years at "291" had really done for me — all my work, all my many and nasty experiences had all helped add to prepare me for the tremendous experience ..."[36]

In the years 1911 through 1917 he devoted himself to sharing this experience with America. At "291" it became new names, new ideas in art. "291" became more and more a laboratory, a place for experimentation, the hope of young artists. On the walls of the gallery appeared the most advanced art of the day. In Paris, Steichen faithfully supported Stieglitz' endeavors. He wrote:

"... I keep wondering how things are over there with you at 291 ... From your letter it looks as though you were going to run a season again next year — I really had hoped you would like a rest ... I think we should, if we have two shows, have one!!! and the other — well an "understandable" one — I had thought some of Charles Shannon's lithographs — or drawings by Gordon Craig — I think I can get both, as for the red rag I am sure Picasso would fill the bill if I can get them — but he is a crazy galloot, hates exhibiting, etc. — however, we will try him. Of course, I do not see the necessity of so much stuff outside photography unless we decide on a new policy of work ... don't hesitate to call on me for as much as I can do over here — I can get any amount of material you know and it will all be good ..."[37]

From Steichen, Stieglitz received and introduced to America during the years 1911-1914, the work of Cézanne, Gordon Craig, Picasso, Arthur B. Carles, and Constantine Brancusi. In the first exhibition of the season 1910-11, appeared work by Cézanne, Renoir, Manet, Toulouse-Lautrec, and Henri Rousseau, the French primitive painter, whose paintings were brought to "291" by his friend Max Weber. Weber's work was shown in the following exhibition, and was described by one critic as "... a brutal, vulgar and unnecessary display of art-license." Stieglitz considered this exhibition a warm-up for the two major events of the season, an exhibition of water colors by Cézanne in March, 1911, followed by the first exhibition of the work of Pablo Picasso in America, from March 28, 1911 to April 25.

At this time, "291" was the only place in America where modern art was being continually shown to the public. There were a few dealers in New York who would occasionally give painters such as Steichen and Weber a show, but they were very few. But slowly something was happening, and it was happening outside, in the small museums, as well as in New York. The directors who had known Stieglitz through his efforts in photography, watched his exhibitions with interest, and then began to participate in his cause. Cornelia B. Sage at the Albright Art Gallery, and John Trask of the

Pablo Picasso: *Drawing* (1910)

Pennsylvania Academy of Fine Arts, both requested and received from Stieglitz, in 1911, loan shows of the work of John Marin. The Rhode Island School of Design also hung a show of Marin's work in 1911, borrowed from Stieglitz, and the Boston Museum of Fine Arts requested his support for an exhibition of the work of Matisse. There was interest and encouragement for Stieglitz and for modern art, but it still seemed to him that he was the only one who really knew what was happening.

With characteristic fervor, he sought to show a blind nation that art had new meaning. He was especially impatient with photographers who could not, or would not, understand his apparent shift of allegiance. Scornfully he wrote:

"...I know as a fact that the photographers of this country are not very eager to see. And that is why their photographic work is not developing. They may be improving technically as far as processes are concerned but they are adding nothing to their own vision. They have no vision. And where in the world are those photographers who really believe in photography..."[38]

It is significant that this statement was contained in a letter to a dissatisfied *Camera Work* subscriber. From January, 1910, through its next to last issues, the magazine contained very little photography, but published the graphic work of Rodin, Matisse, Picasso, and other important new artists, as well as such literary experiments as the writing of Gertrude Stein. It was published despite rising expense and continuous labor. In order to maintain the quality he demanded, Stieglitz was forced to have the plates for the reproductions made in Munich, while the Japanese tissue had to be shipped from Scotland. Added to these difficulties, subscriptions fell off steadily, until finally, with the publication of the number devoted to reproductions of Rodin's drawings, half the subscribers withdrew at once.

In spite of such indifference, Stieglitz continually reaffirmed his beliefs. Annually, he showed the work of Marin, Hartley and Dove. He exhibited Negro sculpture as art, not anthropology, and the painting of untaught children for its value as fresh expression. Among the painters who were introduced to America during the last few years of "291" were Francis Picabia, Alfred Frueh, Georges Braque, Stanton Mac-Donald-Wright, Gino Severini, and the sculptors Constantine Brancusi and Elie Nadelman. In May, 1917, "291" held its last exhibition, a one-man show of the American painter Georgia O'Keeffe. In all the years that he devoted his time and labor to the demonstration of modern art to an unreceptive nation, Stieglitz showed his own photographs at "291" only once. But that one exhibition was of special importance.

It was held from February 24, 1913, to March 15, concurrently with the International Exhibition of Modern Art, organized by the Association of American Painters and Sculptors, and hung in the 69th Infantry Regiment Armory in New York. This exhibition, which had been brought together by Arthur B. Davies, Walt Kuhn and John Quinn, consisted of no less than 1600 works, a colossal assemblage of the trends of European art, with a small representation of the modern American painters. By contrast, the exhibition of Stieglitz' work was intended to show that photography was no longer dependent on the imitation of painting, but would henceforth seek its own aesthetic salvation through straight techniques. Again it was a demonstration by Stieglitz of his comprehensive view of the relation of photography to the other media, for he had planned the exhibition ever since the organizers of the Armory show had come to him for advice on where to obtain the best of modern art. He himself had contributed to the show a number of works by some of the painters he was supporting. It turned out to be an astonishing affair. The crowds swarmed through it. Egged on by

Gordon Craig: *Ninth Movement* (1909)

Paul Strand: *Photograph—New York* (1915)

a generally sarcastic press, they came to jeer and to laugh at the new art. But with the astounding publicity, its comprehensive size, and its tour of Chicago and Boston, it was the salvo that launched the full-scale attack of modern art on America. It fully eclipsed the years of effort at "291." Stieglitz wrote to a friend:

> "...The Big International Exhibition was held at the Armory, and was really the outcome of the work going on at '291' for many years, was a sensational success, possibly primarily a success of sensation. One thing is sure, the people at large and for that matter also the artists, etc. have been made to realize the importance of the work that has been going on at '291' and in *Camera Work*. This much the Exhibition accomplished for us..."[39]

Among the many people who had come to "291" and experienced the impact of the images they saw there, was a young student named Paul Strand. The beauty of the prints by the Photo-Secessionists inspired him to master photography. Again and again he went back to the little gallery. Stieglitz showed the young photographer his own photographs and shared with him the realization that photography had a new potential, new goals in an objective world. For several years Strand went to Stieglitz, taking new work and seeking counsel. At the same time he continued to feel the force of the exhibitions at "291." Like so many other photographers, the exhibitions of Matisse, Picasso, and the other new artists, were incomprehensible to him. But gradually he explored the basic elements upon which this new vision was based until finally he found in them a foundation for his own creativity.

In 1915, he brought to Stieglitz a series of photographs showing an approach to the medium surpassing any that had gone before. In the streets of New York he stalked images of the crushing forces of the city. The people he saw were those from whom the city had torn all dignity. The metropolis he saw was one which overpowered its inhabitants with terror and degradation. When he saw beauty it was in the abstract form of the patterns made by bowls or a picket fence. Stieglitz was so impressed that he immediately made plans to show them.

The exhibition, Strand's first one-man show, was held at "291" from March 13 through 28, 1916. It was the only exhibition of photographs to be held at "291" during the last four years of the gallery, and was timed to appear concurrently with the "Forum Exhibition of Modern American Painters," held at the Anderson Gallery in New York. This was the first major exhibition of modern art to be held in America since the Armory show, just as Strand's photographs were the first major exhibition of photography since the Stieglitz exhibition at "291."

The exhibition occupied a brief moment in time and then was gone. But in the pages of *Camera Work,* Stieglitz set forth an enduring record of these trenchant photographs. In the October, 1916, issue, Number 48, he published six of Strand's photographs and wrote, "... His work is rooted in the best traditions of photography. His vision is potential. His work is pure. It is direct. It does not rely upon tricks of process ..." Then, as if in a gesture of finality, Stieglitz devoted the last two numbers, 49 and 50, published as a single issue in June, 1917, to Strand's photographs. Again he wrote, speaking of Strand as "... The man who has actually done something from within. The photographer who has added something to what has gone before. The work is brutally direct. Devoid of flim-flam; devoid of trickery and of any "ism"; devoid of any attempt to mystify an ignorant public, including the photographers themselves. These photographs are the direct expression of today ..."

Stieglitz devoted his entire life of creative effort to photography. In the years

which followed those who sought to achieve pure creative work through photography came to Stieglitz. Through his thoughts, through his emotions, expressed by the medium of photography, he led the way. There were more galleries, more battles. Always significant expression, the truth, was what he sought. Great painters, photographers, sculptors found in Stieglitz spiritual and material aid to continue their work. It made no difference to Stieglitz in what medium the artist worked, so long as he himself was sincere, so long as his work was an affirmation of himself. With intense regard for the basic values and principles by which man must live, despite insidious criticism and troubled times, he shaped his own life and art. He shared the values he cherished with his colleagues through letters and conversation, and with the public through his galleries. His own work, and the work of the artists he nurtured, perpetuated his hopes and ideals, vital and imperishable.

PORTFOLIO

David Octavius Hill and Robert Adamson: *Dr. Munro* 67

David Octavius Hill and Robert Adamson: *John Gibson Lockhart*

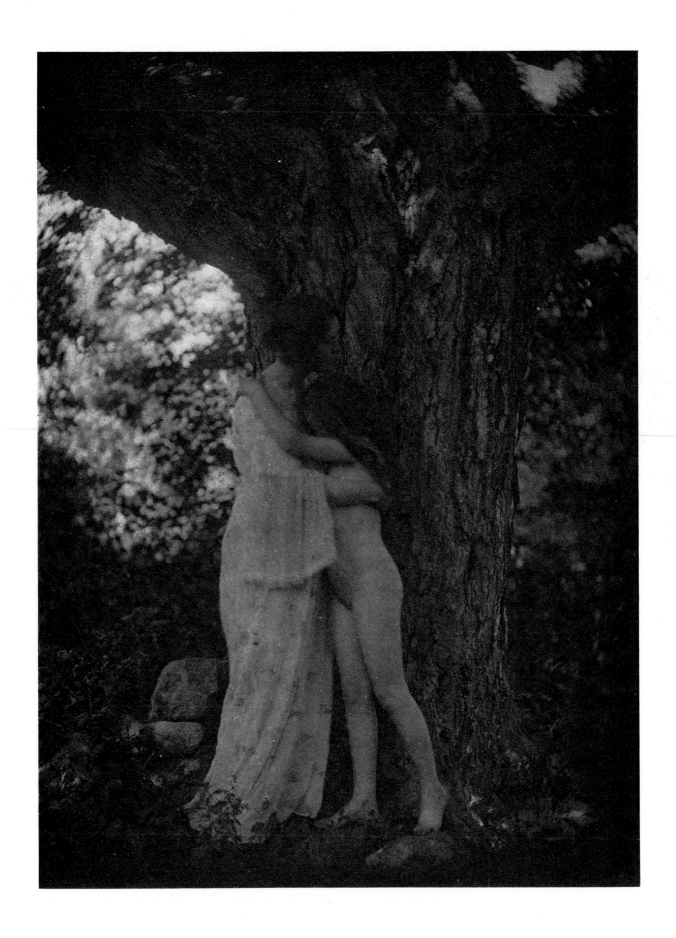

Alice Boughton: *Nature*

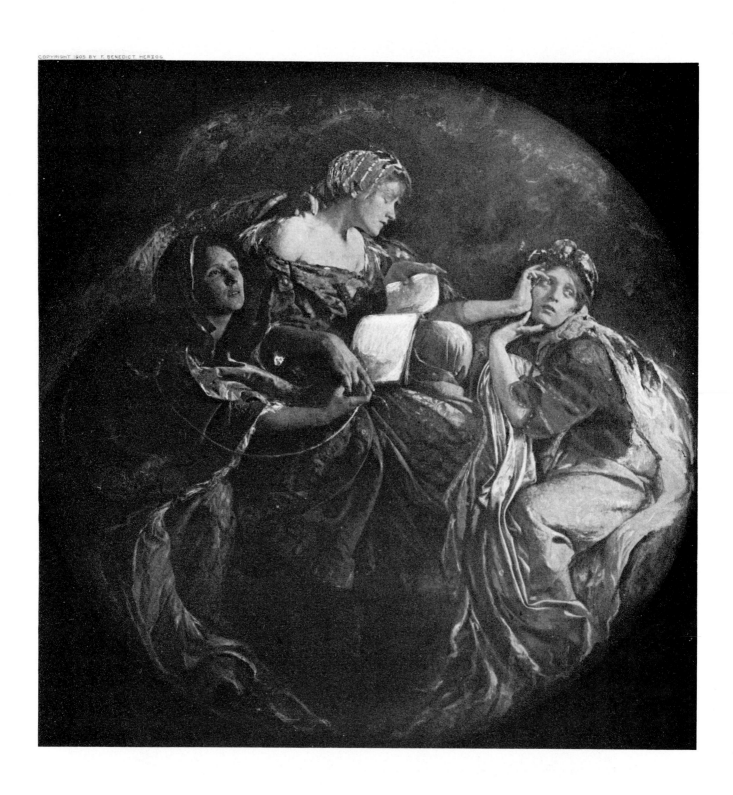

F. Benedict Herzog: *The Tale of Isolde*

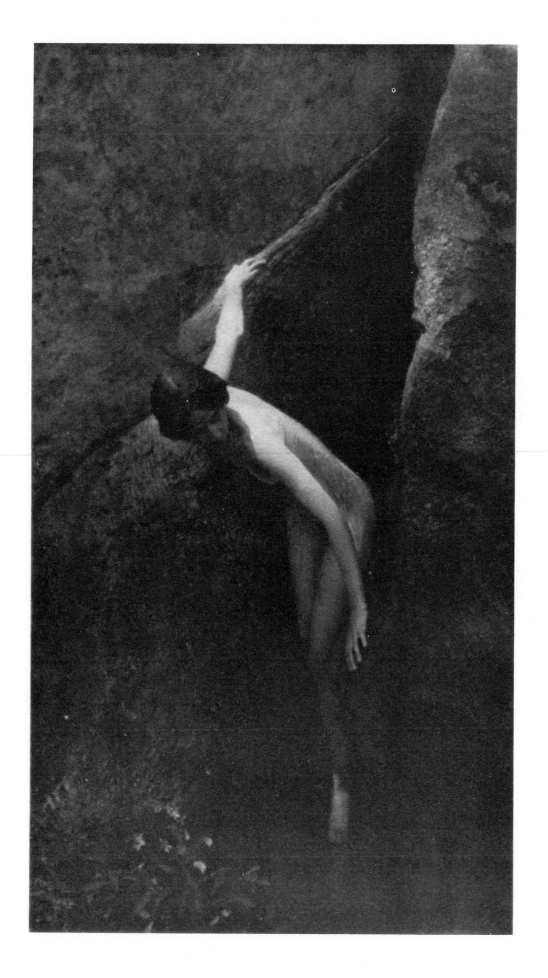

Annie W. Brigman: *The Cleft of the Rock*

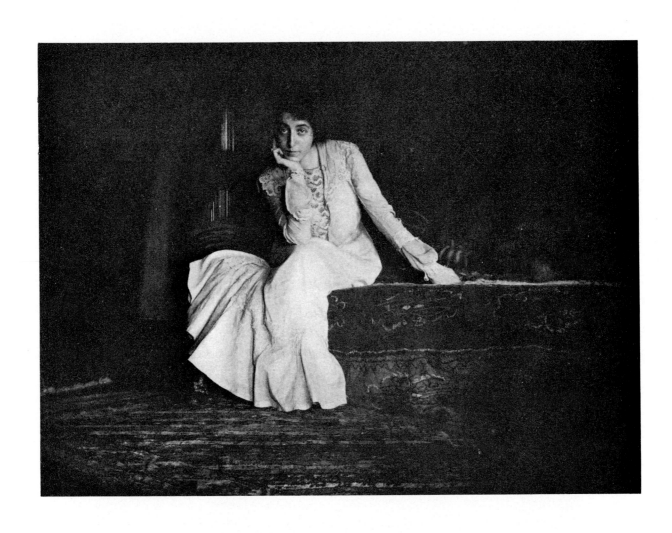

Joseph T. Keiley: *Portrait—Miss De C.*

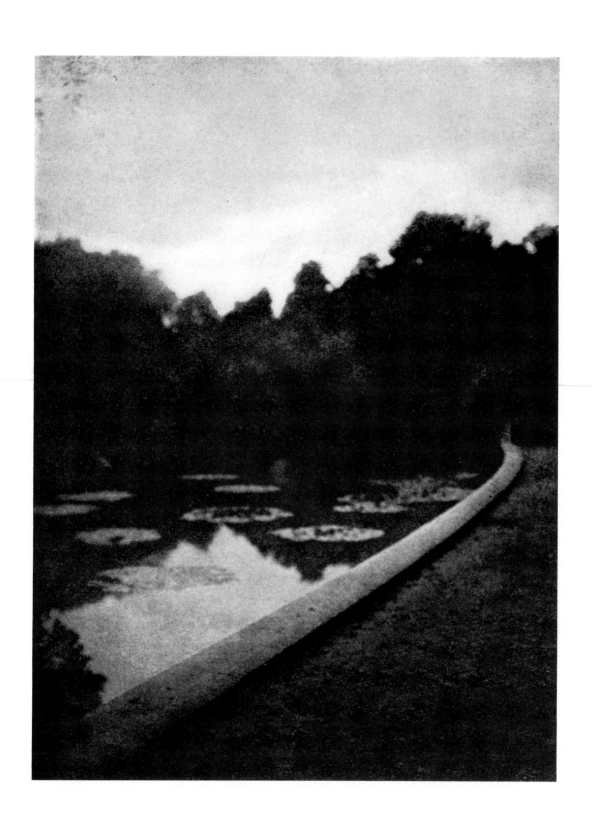

Joseph T. Keiley: *A Garden of Dreams*

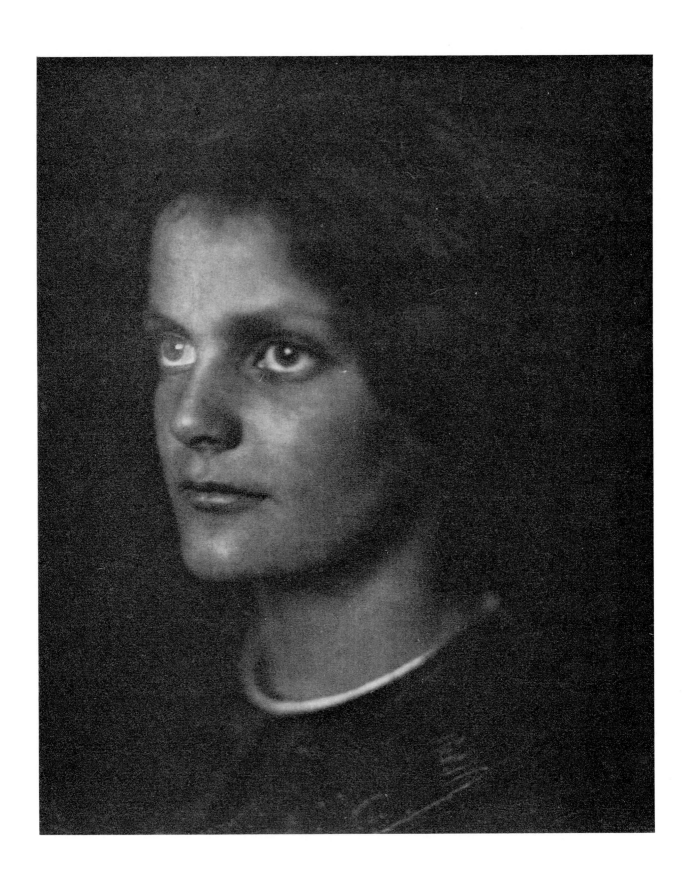

Sarah C. Sears: *Mary*

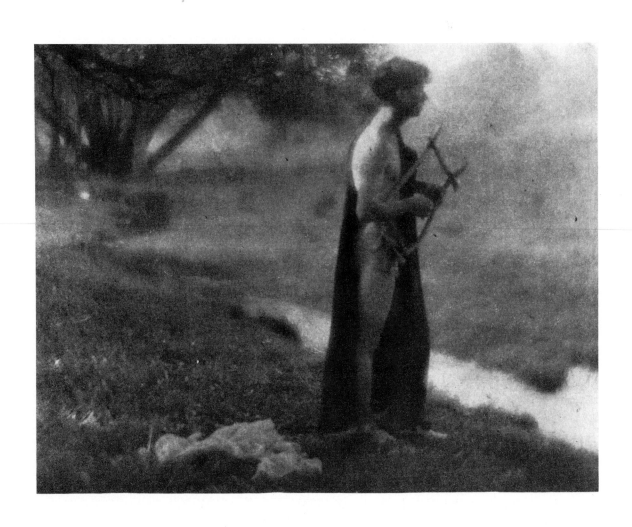

George H. Seeley: *No Title*

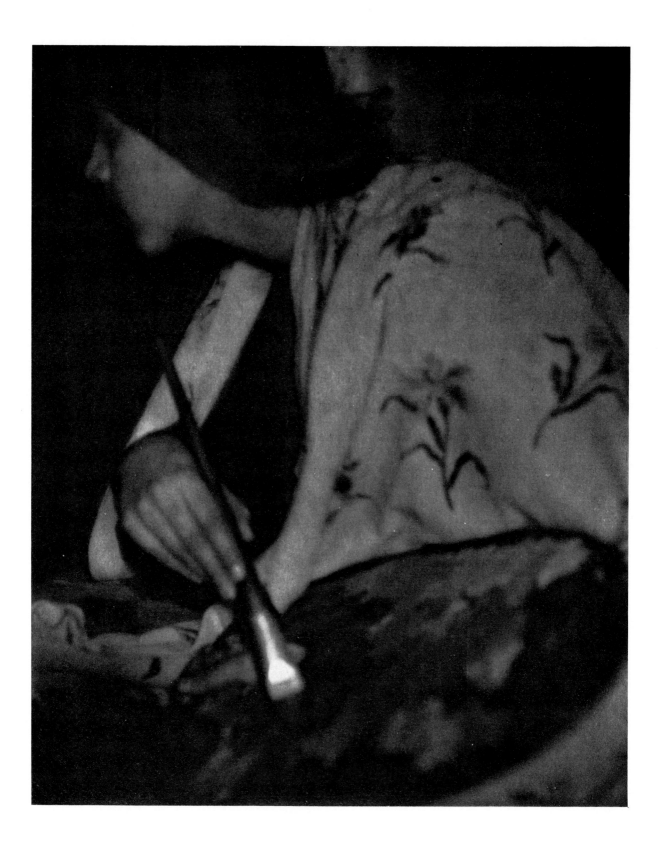

George H. Seeley: *The Artist*

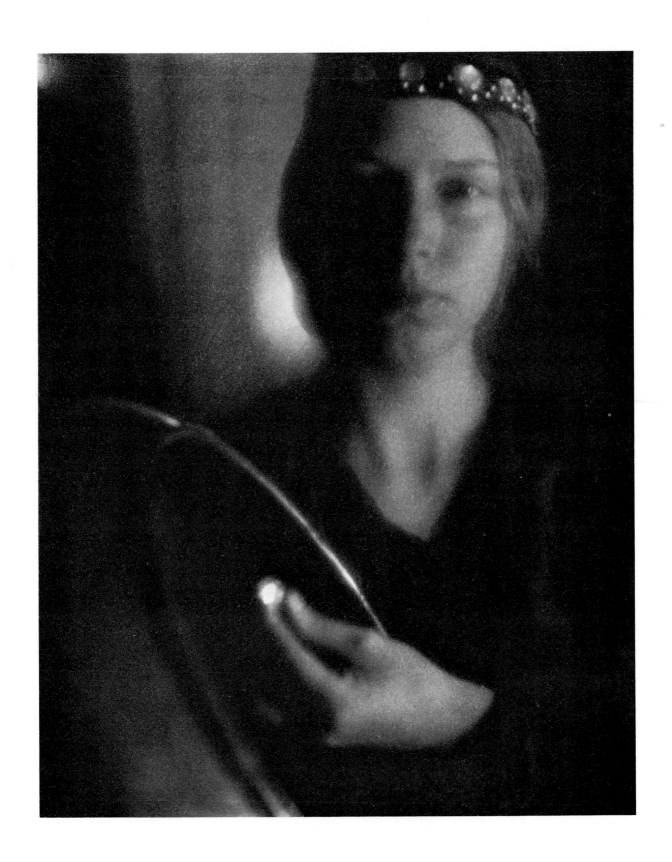

George H. Seeley: *The Firefly*

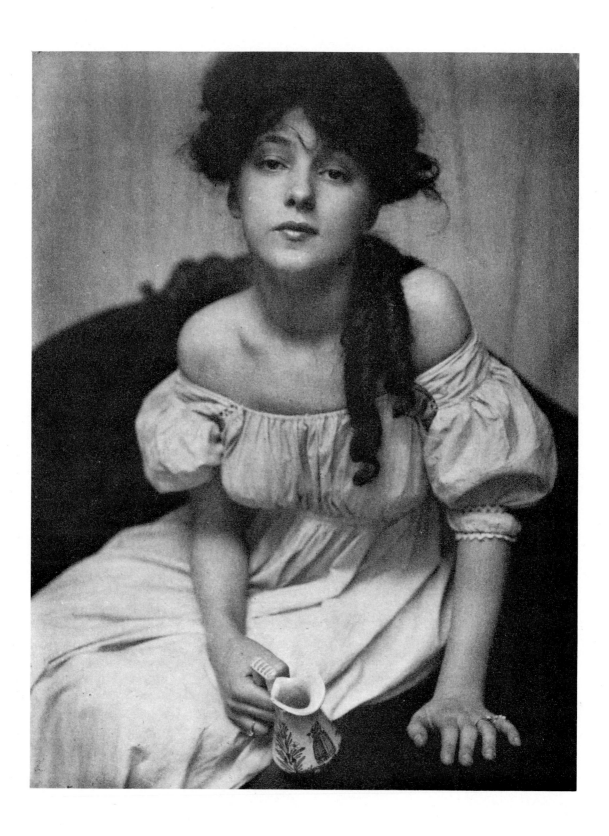

Gertrude Käsebier: *Portrait* (*Miss N.*)

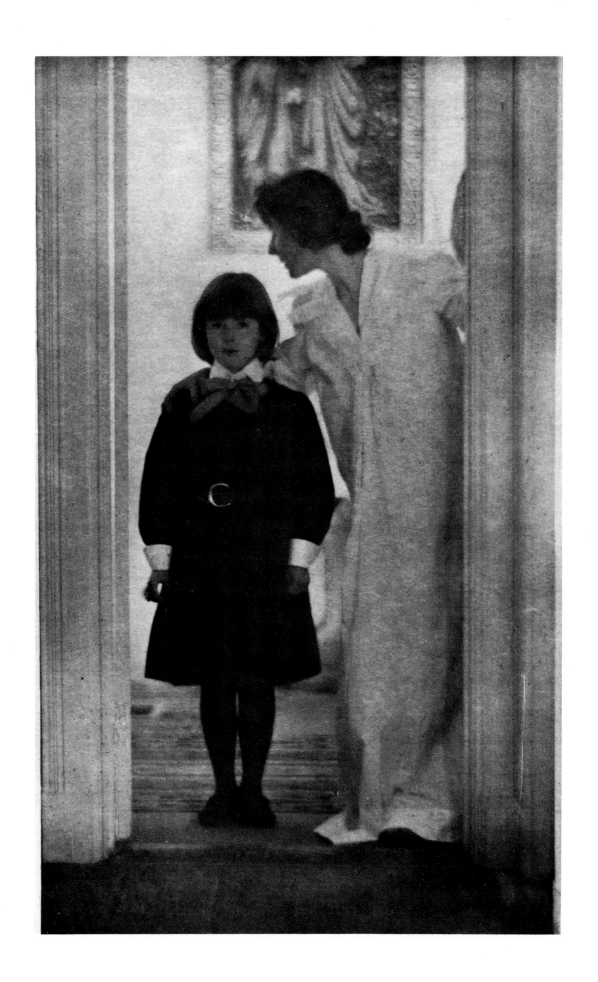

Gertrude Käsebier: *Blessed Art Thou Among Women*

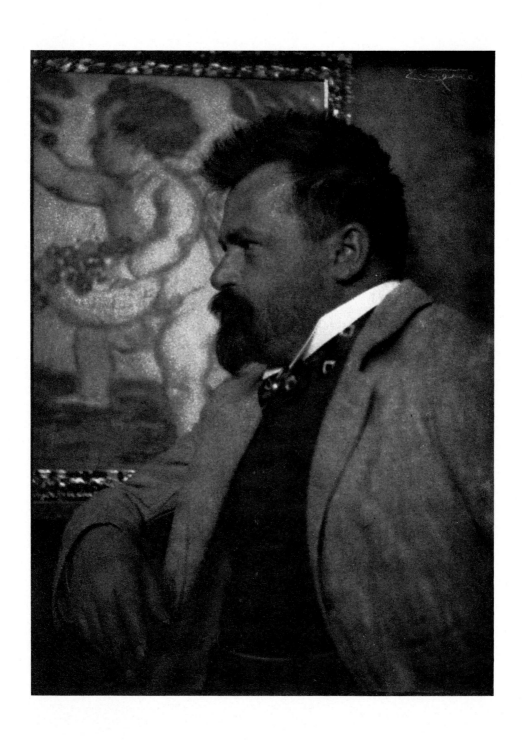

Frank Eugene: *Prof. Adolf Hengeler*

Hugo Henneberg: *Villa Falconieri*

82 Frederick H. Evans: *Ely Cathedral: A Memory of the Normans*

J. Craig Annan: *Stirling Castle*

J. Craig Annan: *The Riva Schiavoni, Venice*

J. Craig Annan: *The Dark Mountains*

Harry C. Rubincam: *In the Circus*

George Davison: *The Long Arm*

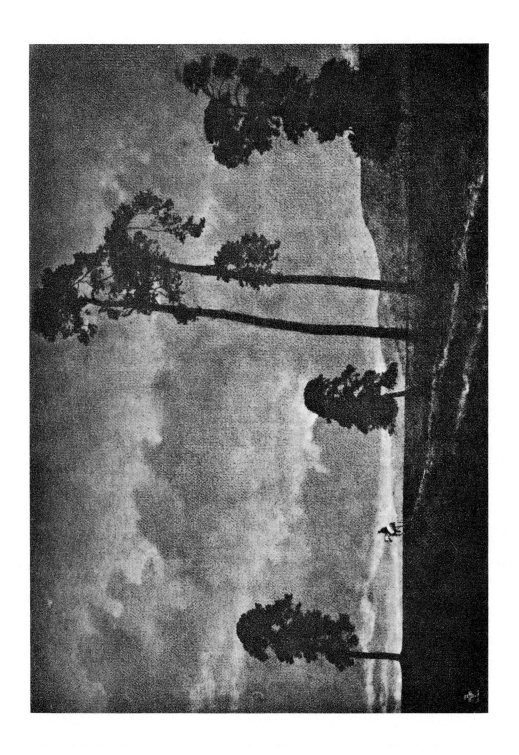

Theodor and Oscar Hofmeister: *The Solitary Horseman*

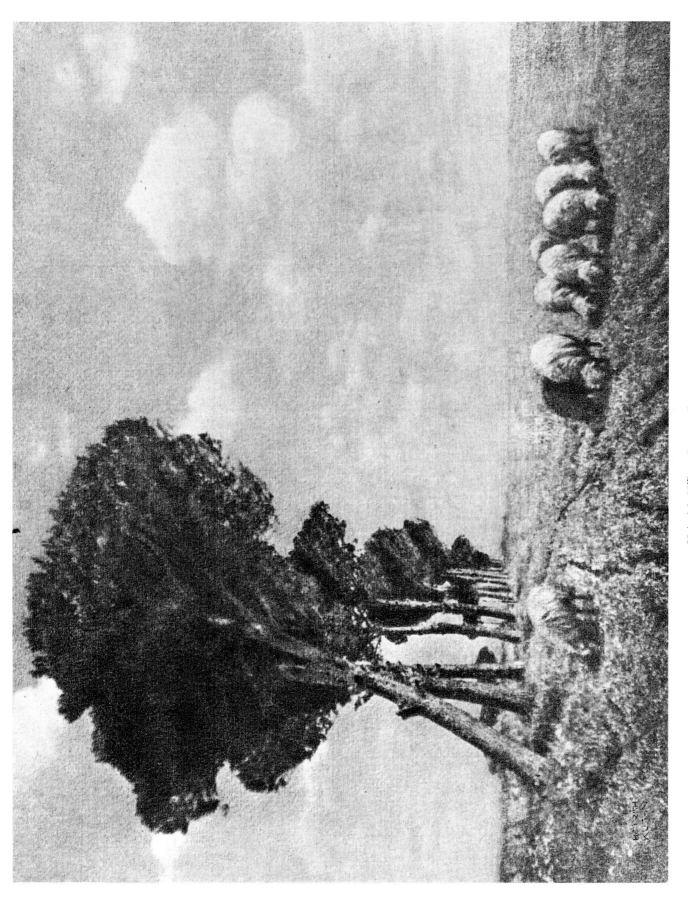

Heinrich Kühn: *Roman Campagna*

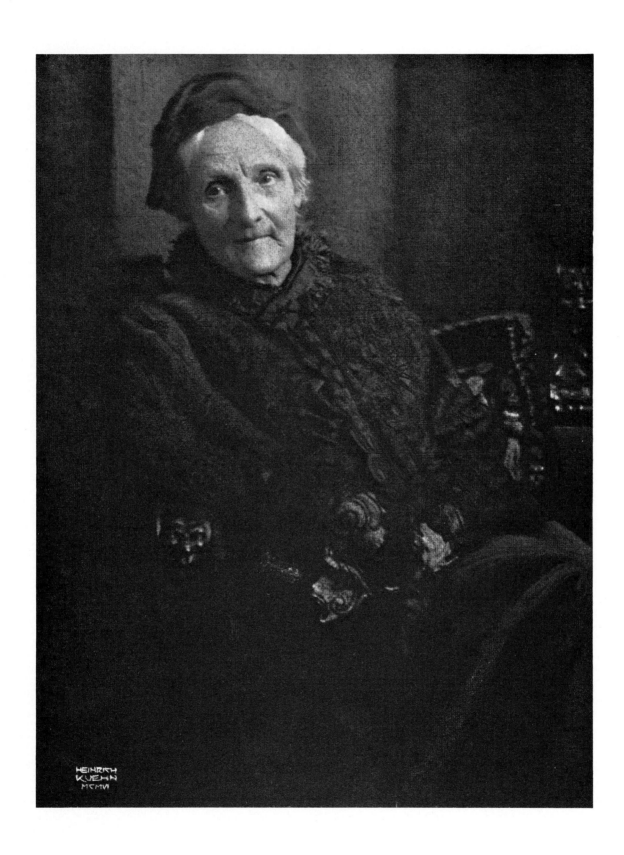

Heinrich Kühn: *Portrait—Meine Mutter*

Eduard J. Steichen: *Moonlight: The Pond*

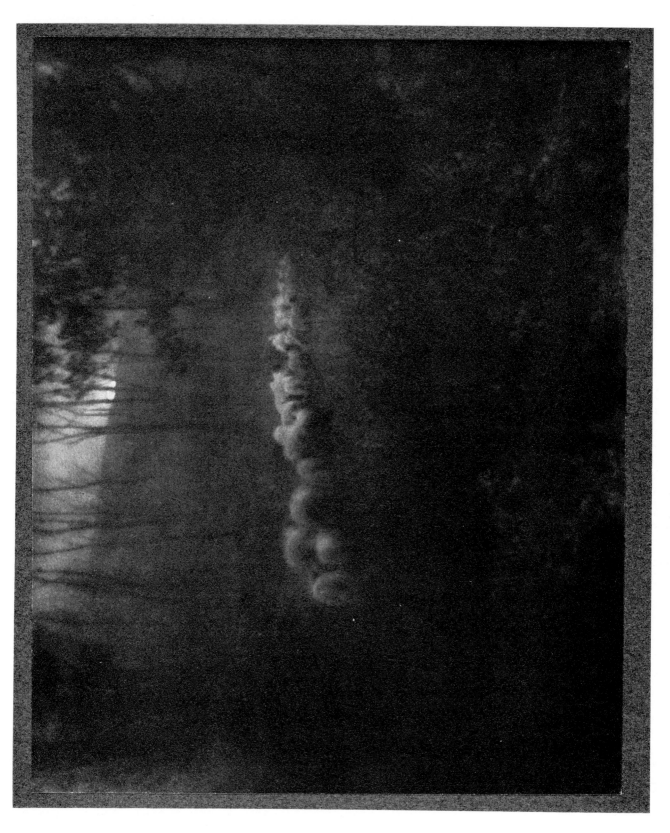

Eduard J. Steichen: *Pastoral—Moonlight*

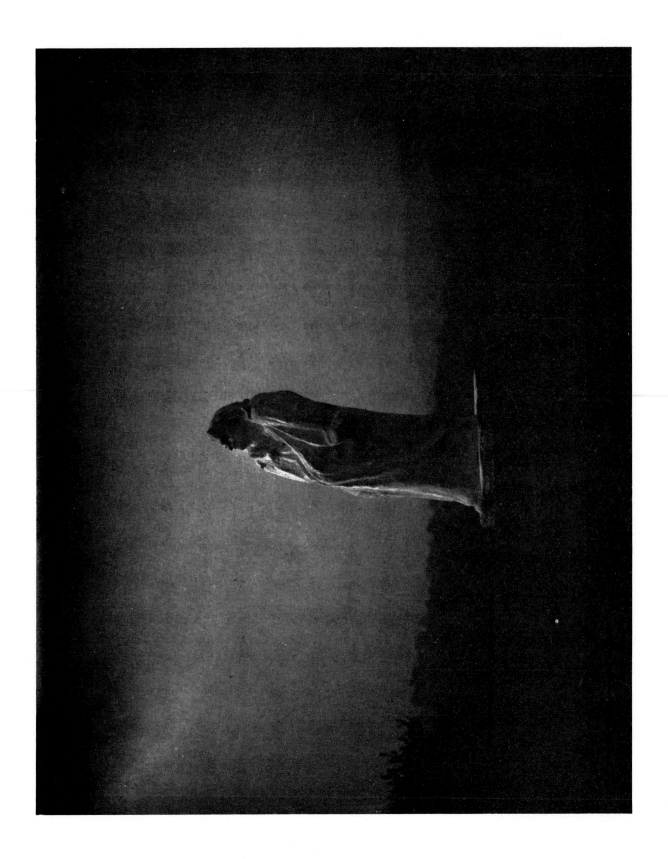

Eduard J. Steichen: *Balzac—Towards the Light, Midnight*

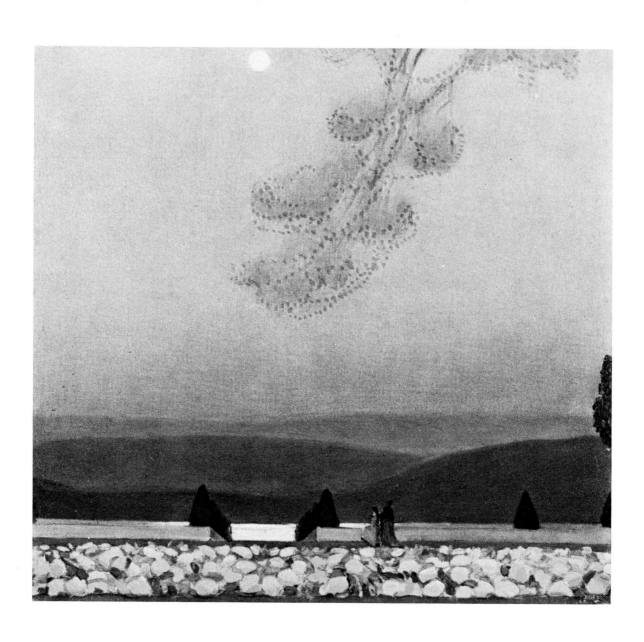

Eduard J. Steichen: *Nocturne—Hydrangea Terrace, Chateaux Ledoux*

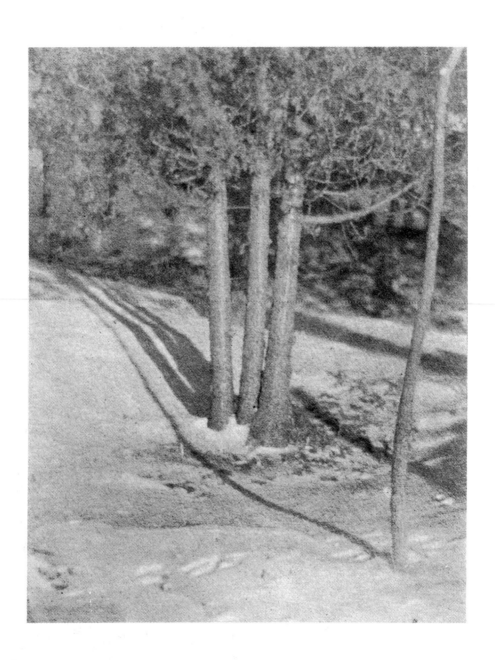

Eduard J. Steichen: *Judgment of Paris—A Landscape Arrangement*

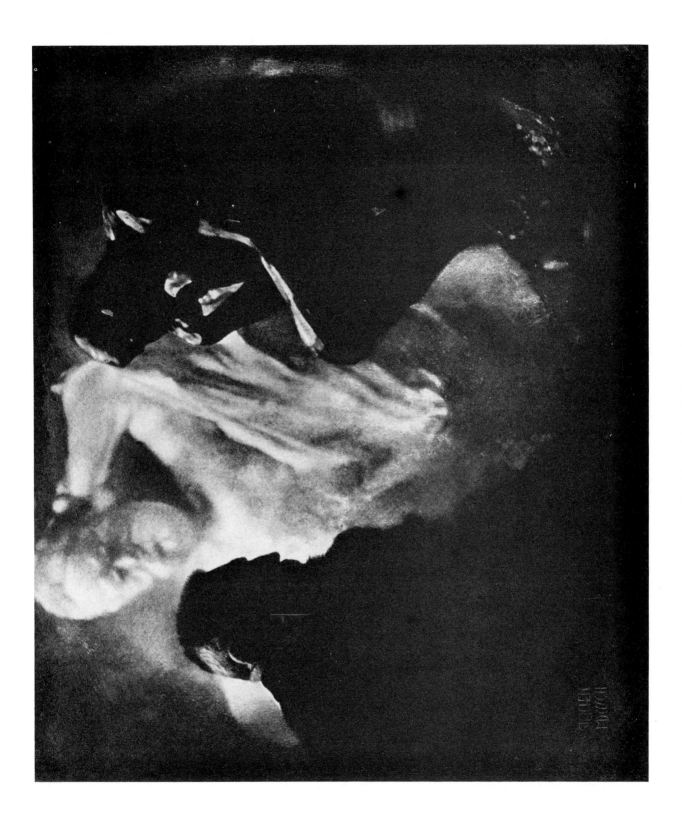

Eduard J. Steichen: *Rodin—Le Penseur*

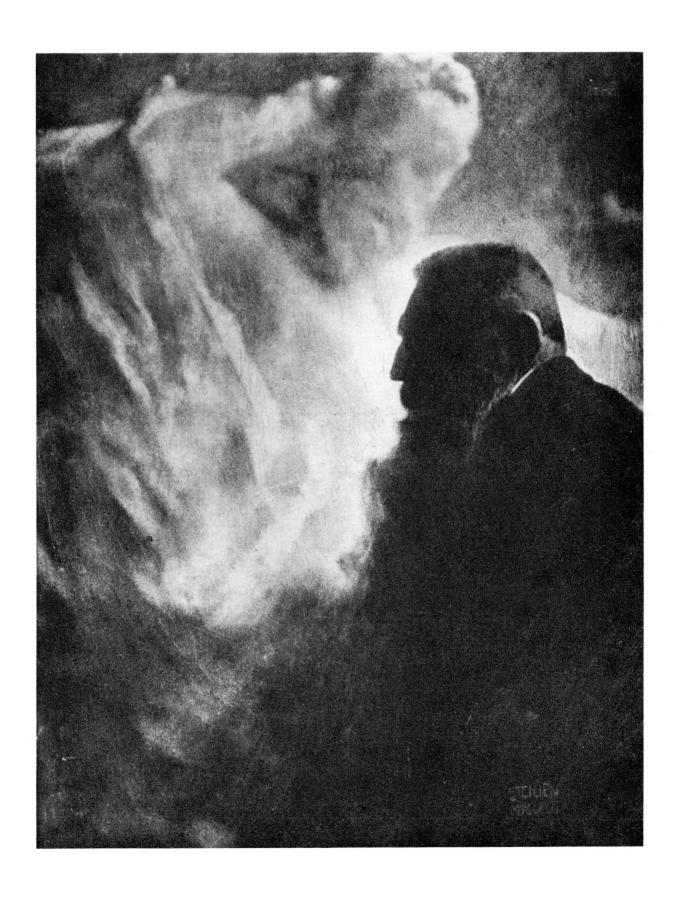

Eduard J. Steichen: *Rodin*

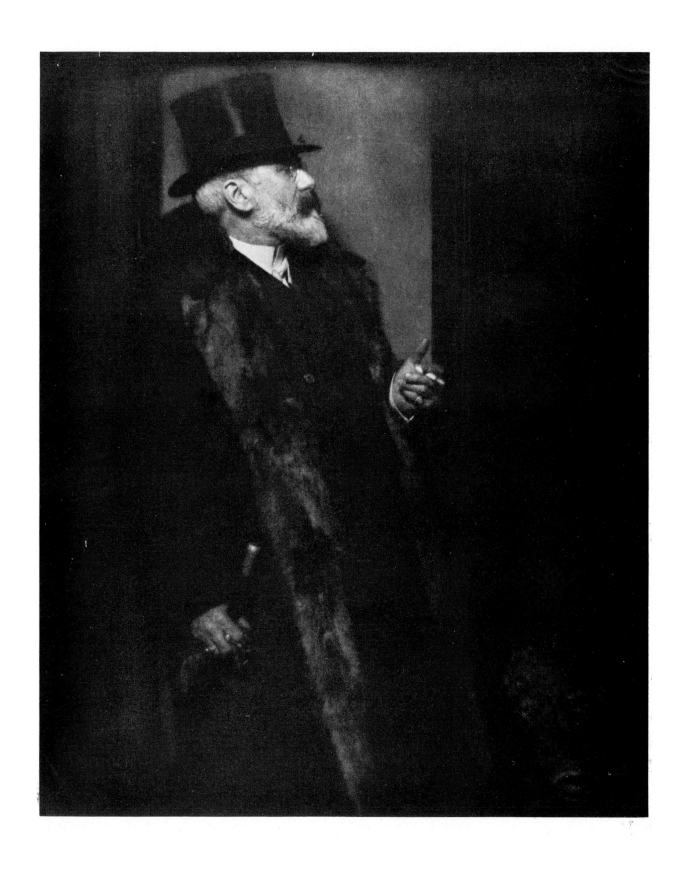

Eduard J. Steichen: *Wm. M. Chase*

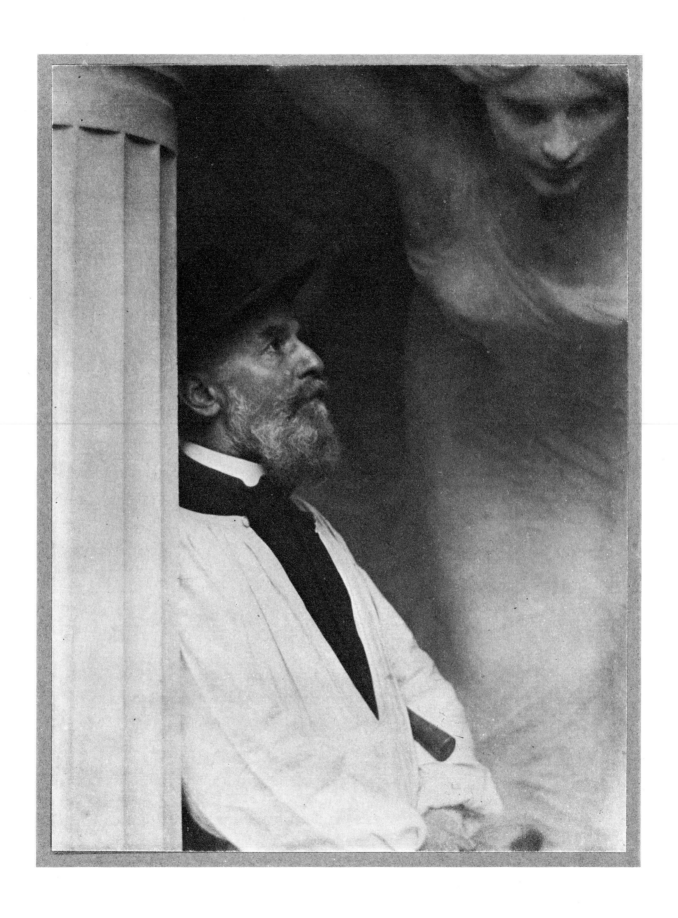

Eduard J. Steichen: *Bartholomé*

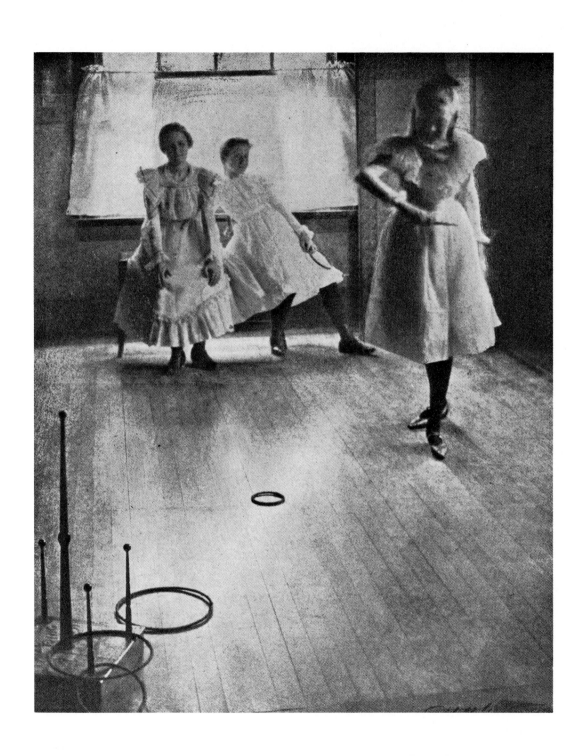

Clarence H. White: *Ring Toss*

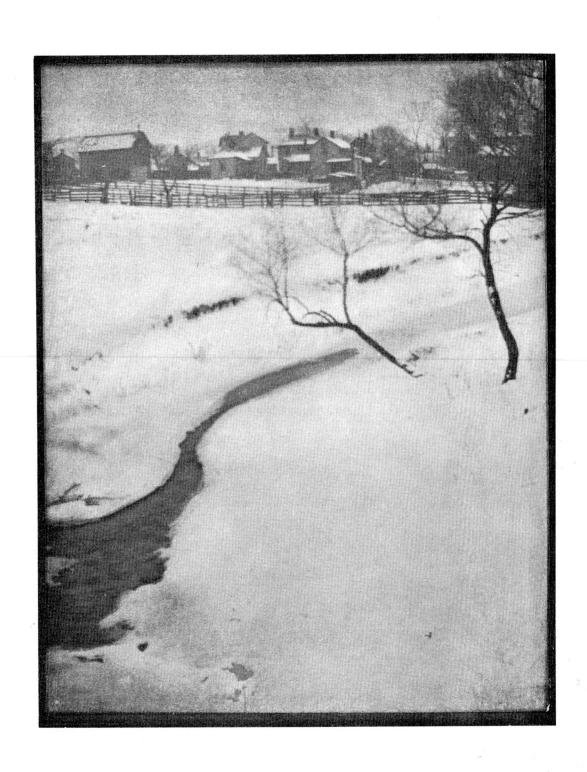

Clarence H. White: *Winter Landscape*

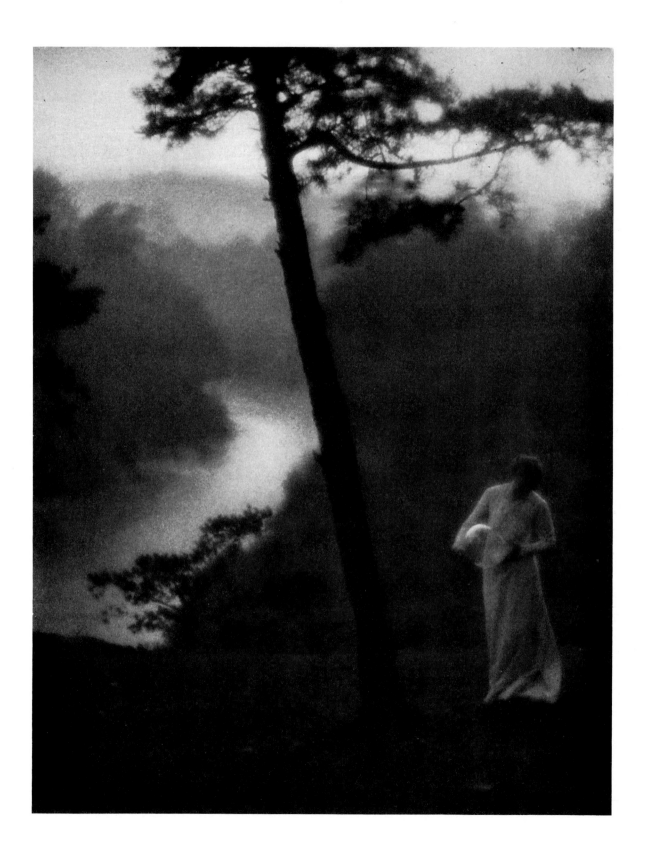

Clarence H. White: *Morning*

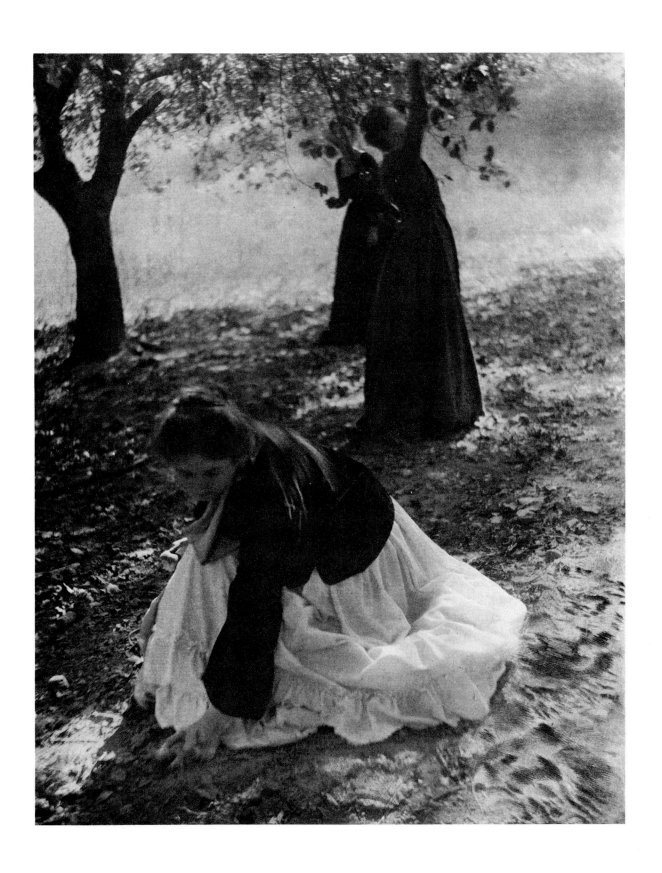

Clarence H. White: *The Orchard*

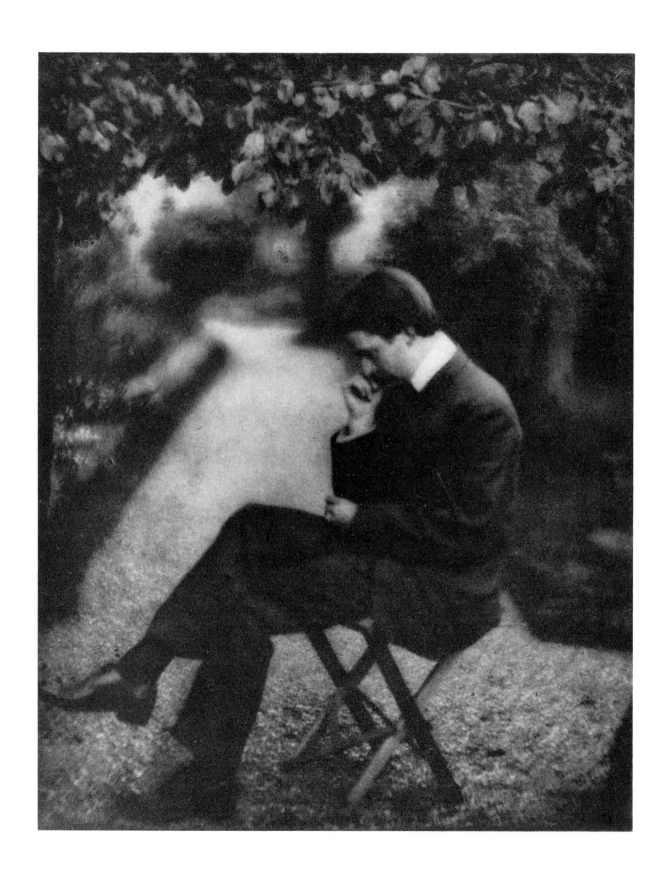

George Bernard Shaw: *Portrait of Alvin Langdon Coburn*

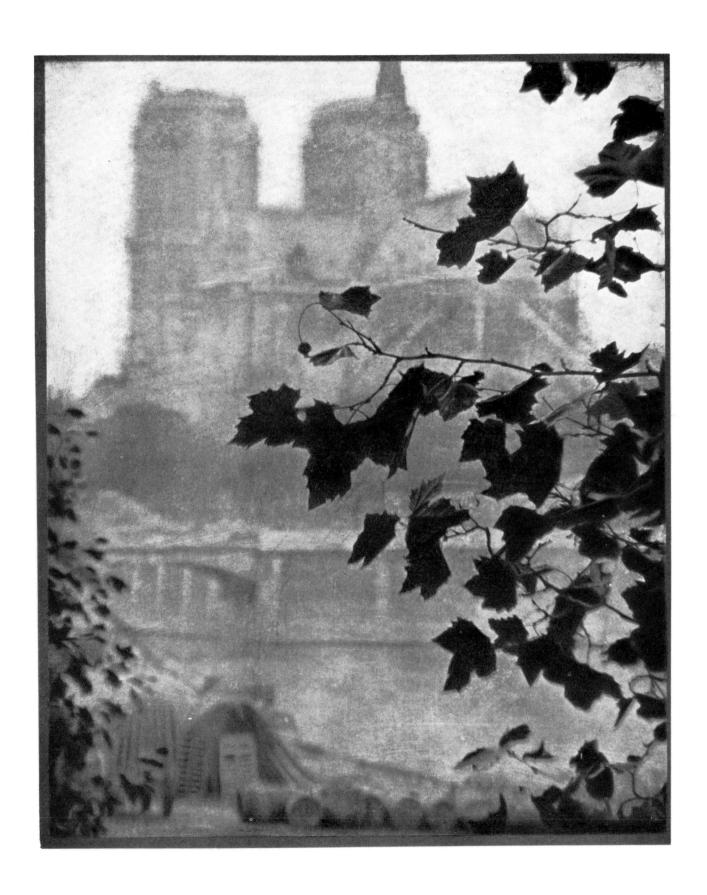

Alvin Langdon Coburn: *Notre Dame*

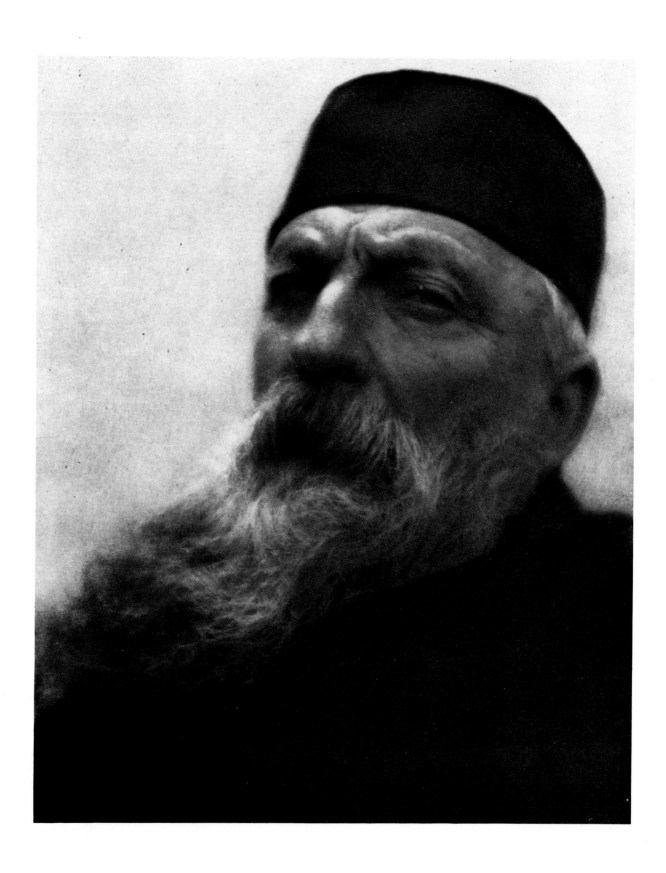

Alvin Langdon Coburn: *Rodin*

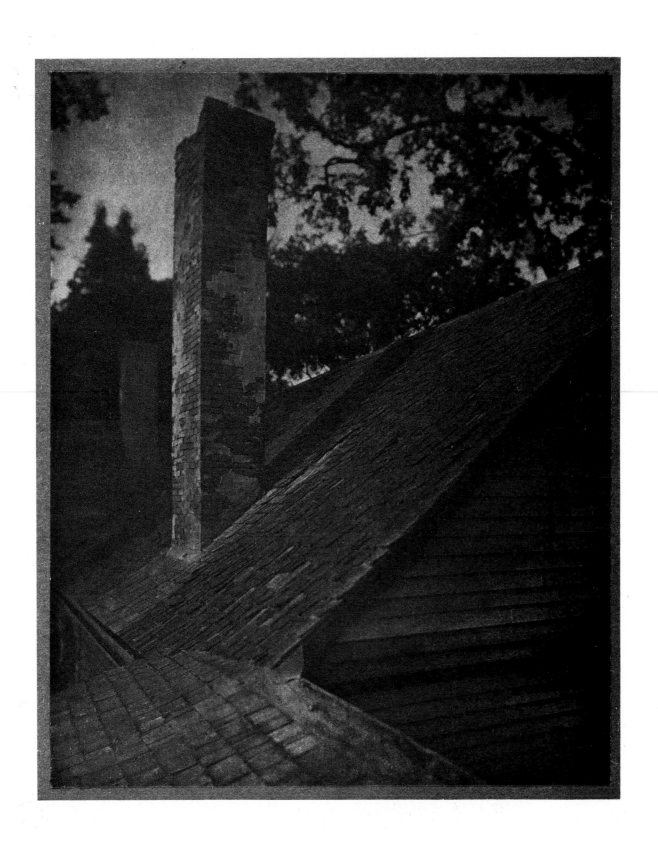

Alvin Langdon Coburn: *Gables*

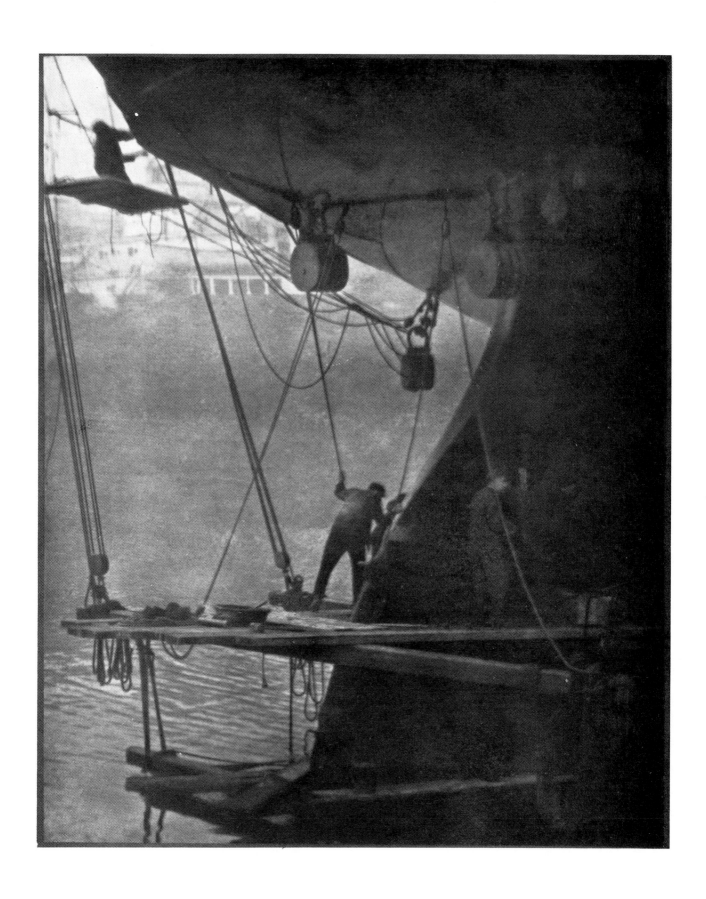

108 Alvin Langdon Coburn: *The Rudder*

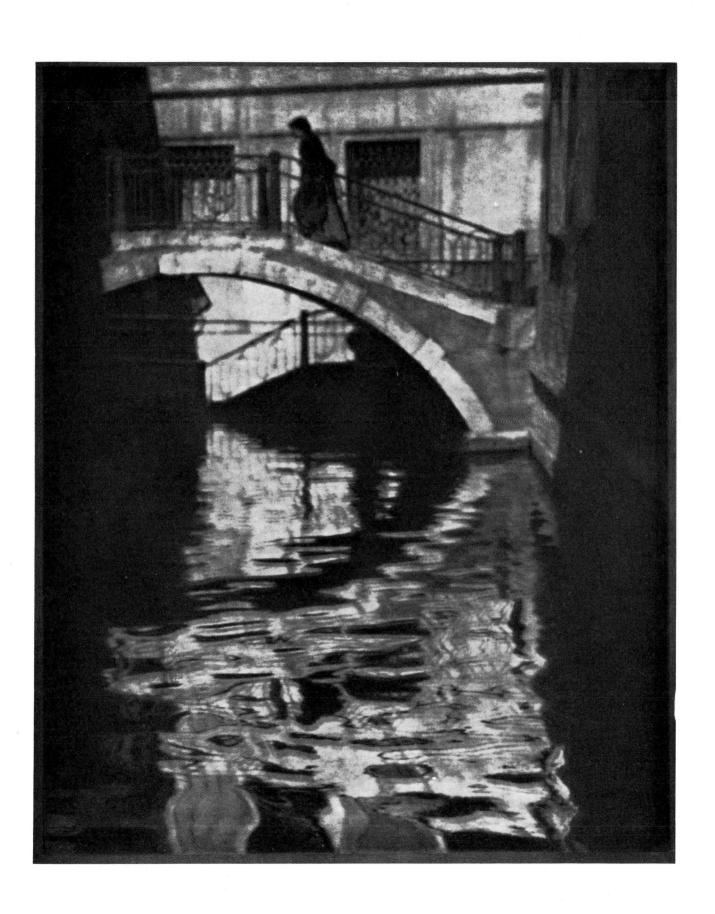

Alvin Langdon Coburn: *The Bridge, Venice*

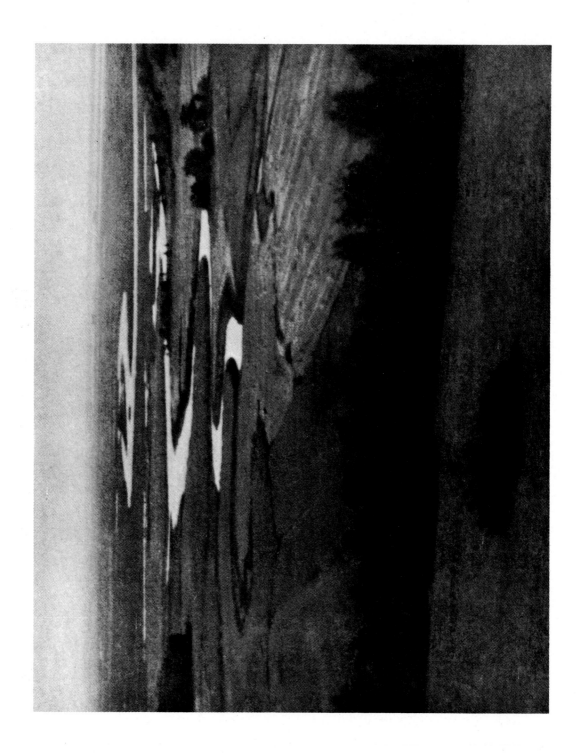

Alvin Langdon Coburn: *The Dragon*

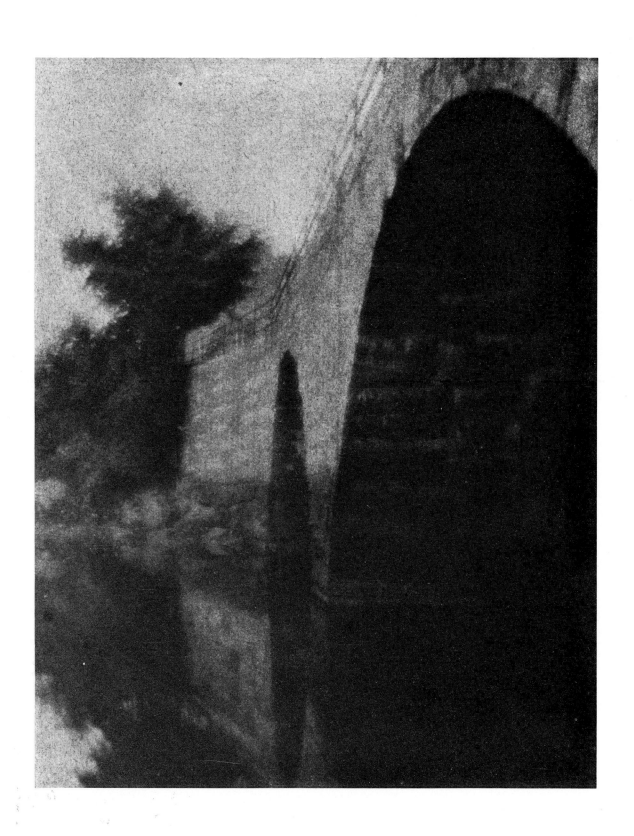

Alvin Langdon Coburn: *The Bridge—Ipswich*

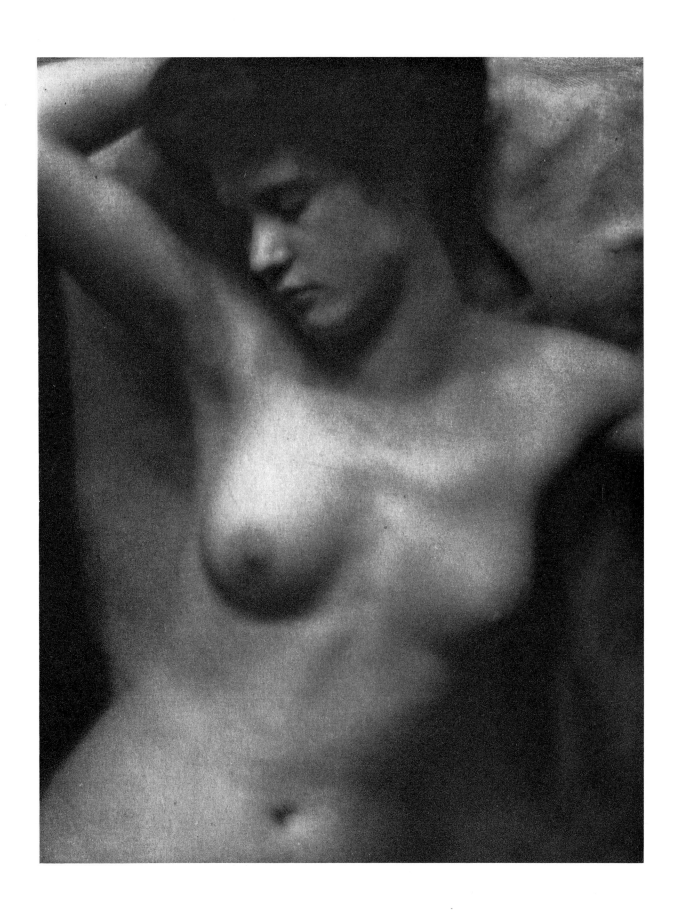

Clarence H. White and Alfred Stieglitz: *Torso*

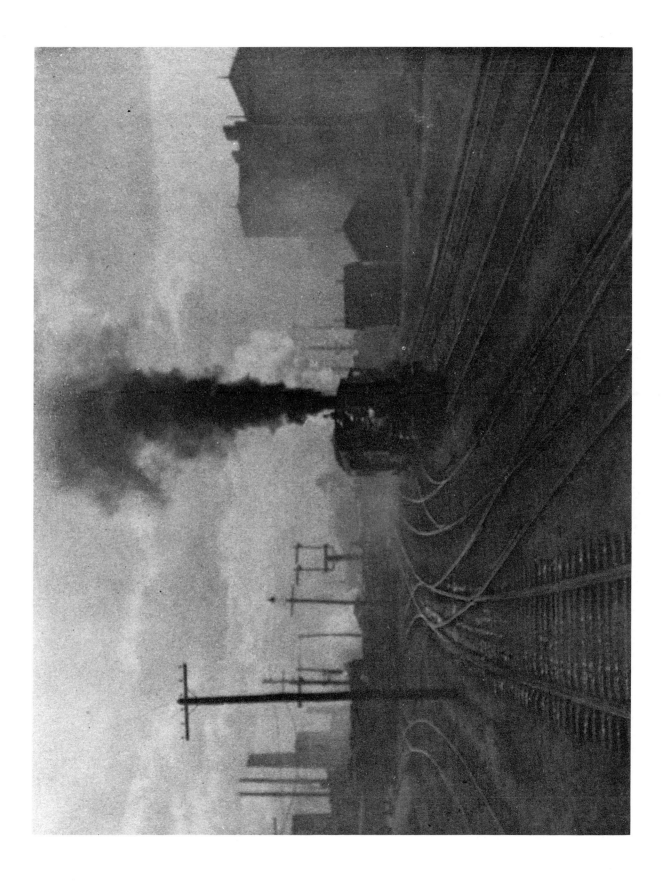

Alfred Stieglitz: *The Hand of Man*

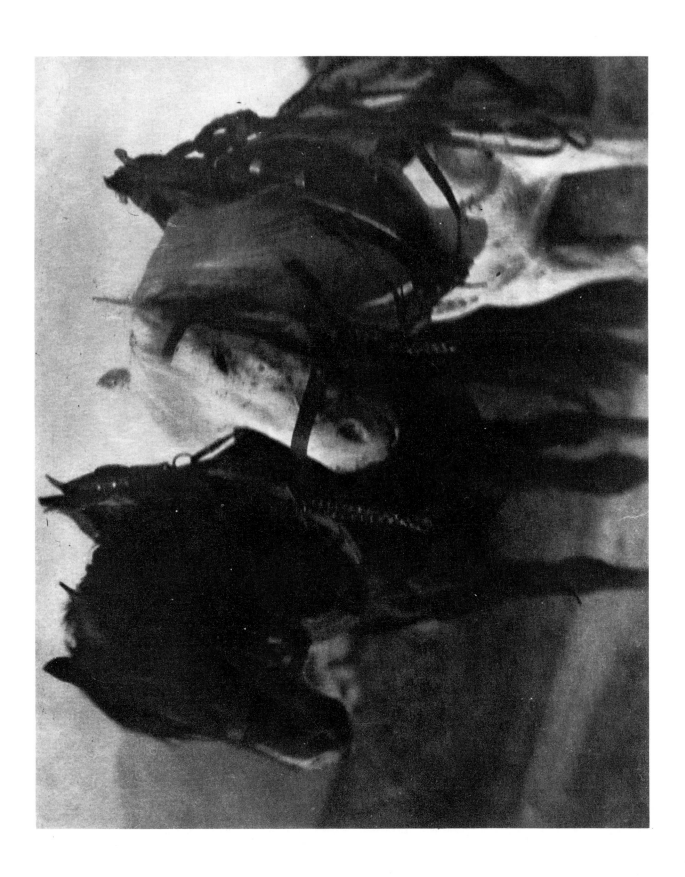

Alfred Stieglitz: *Horses (1904)*

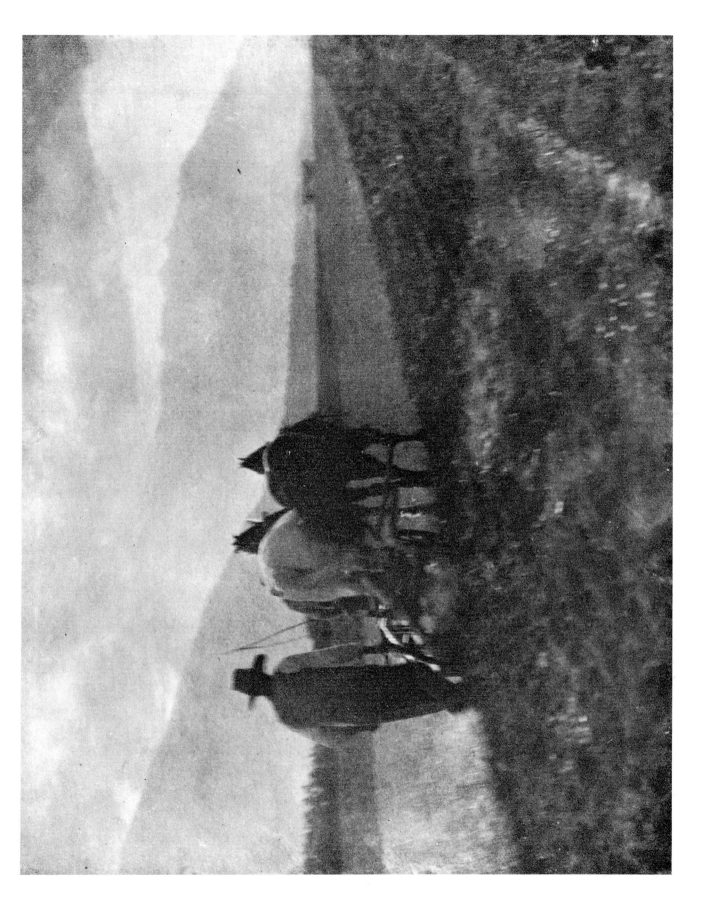

Alfred Stieglitz: *Ploughing* (1904)

Alfred Stieglitz: *Katherine (1905)*

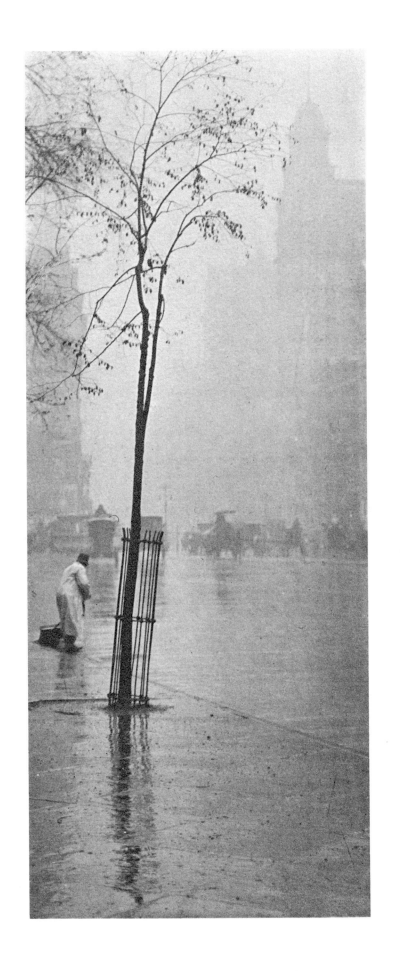

Alfred Stieglitz: *Spring Showers, New York (1900)*

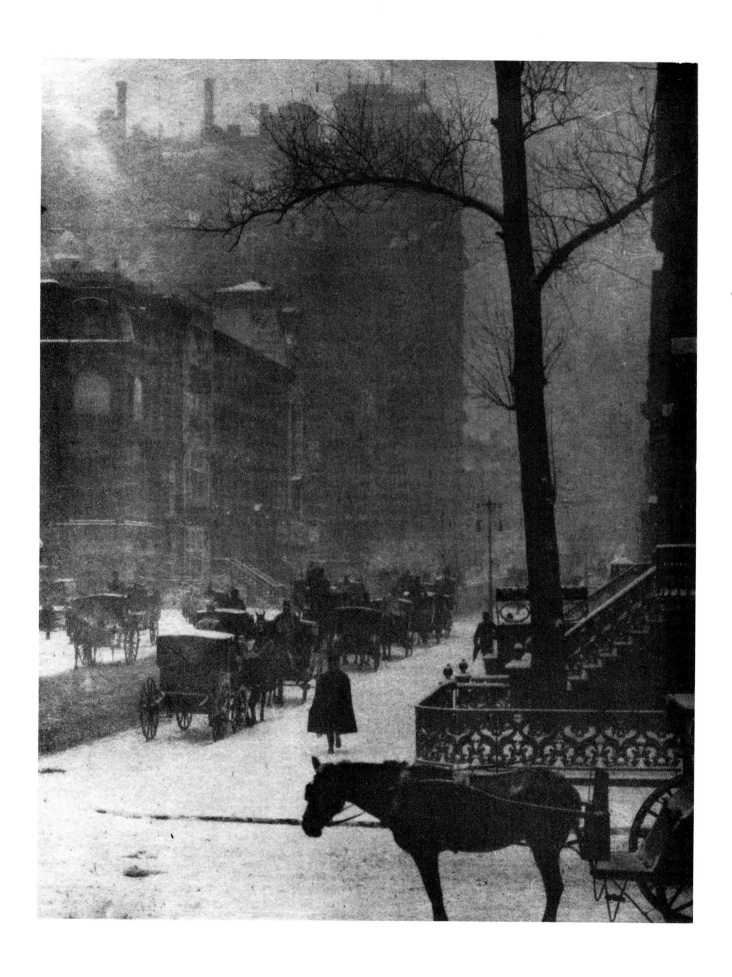

Alfred Stieglitz: *The Street—Design for a Poster*

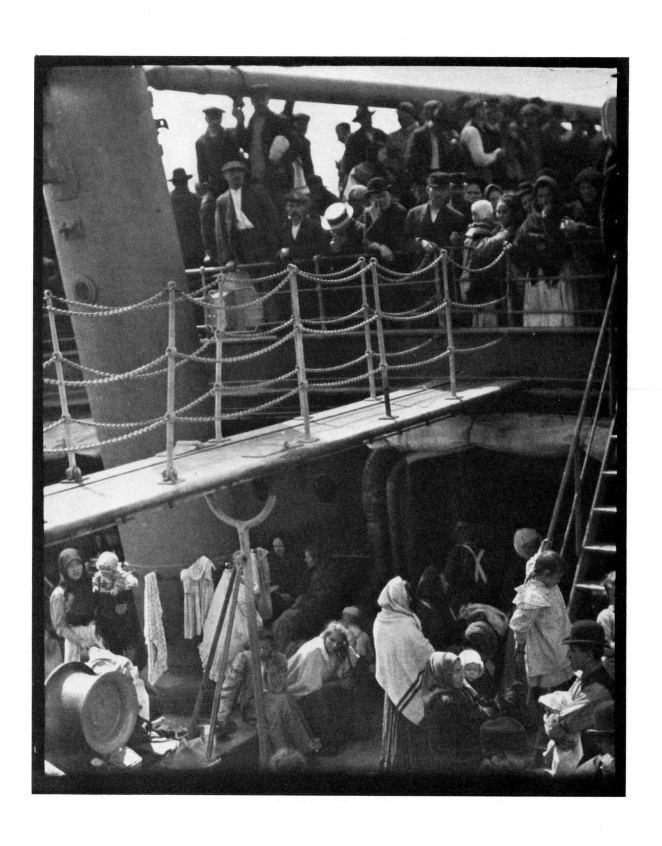

Alfred Stieglitz: *The Steerage (1907)*

Alfred Stieglitz: *The Terminal* (1892)

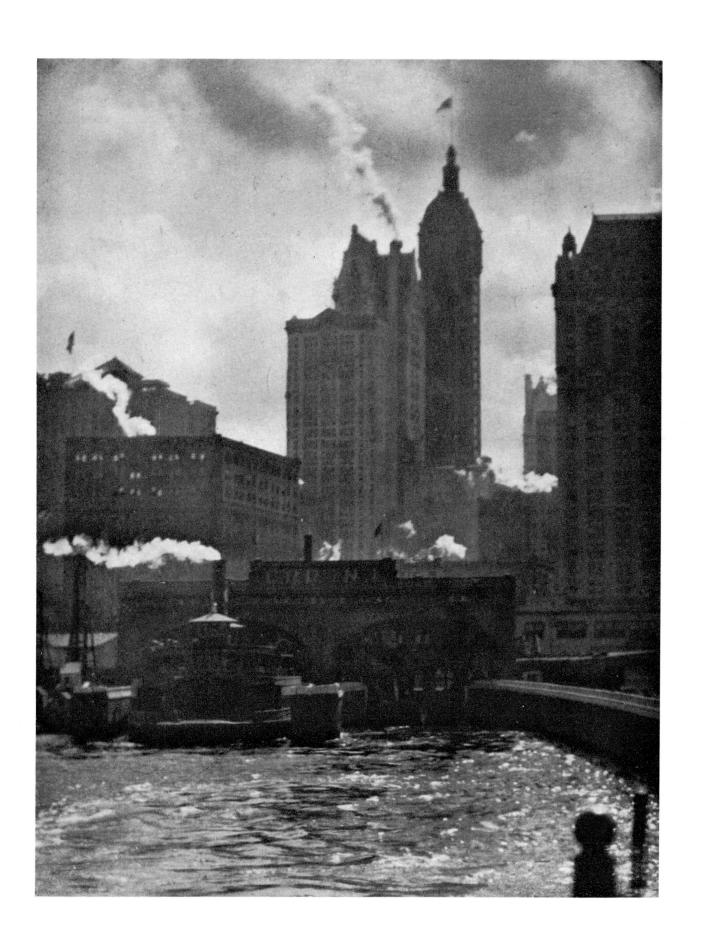

Alfred Stieglitz: *The City of Ambition* (1910)

Alfred Stieglitz: *The Aeroplane (1910)*

Alfred Stieglitz: *The Ferry Boat (1910)*

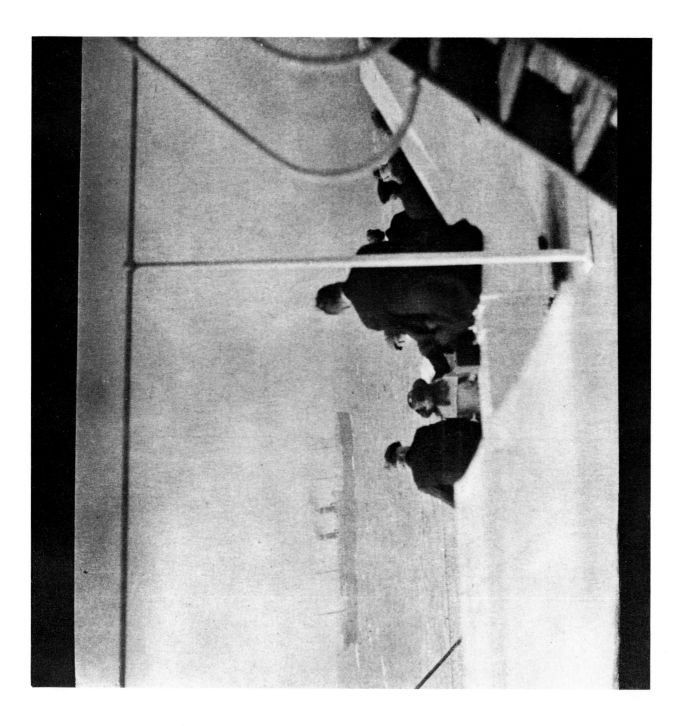

Paul B. Haviland: *Passing Steamer*

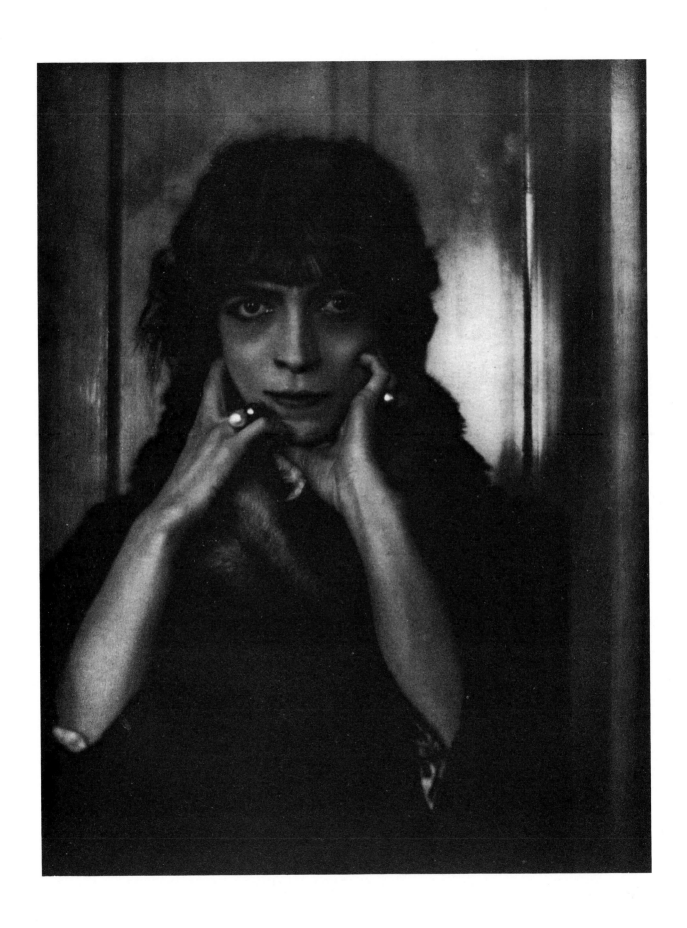

Adolf De Meyer: *Marchesa Casati*

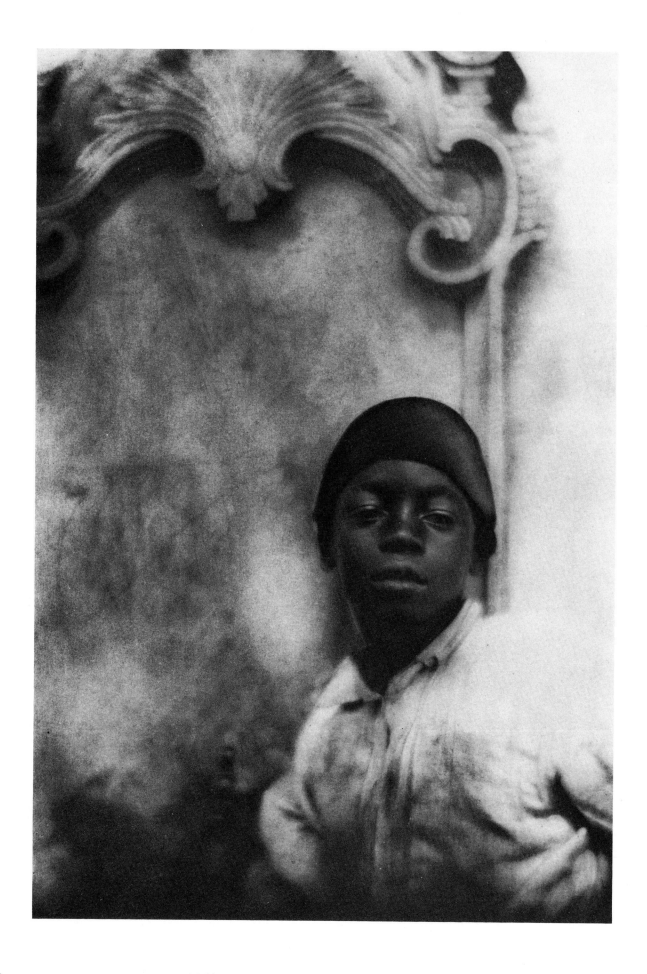

Adolf De Meyer: *From the Shores of the Bosphorus*

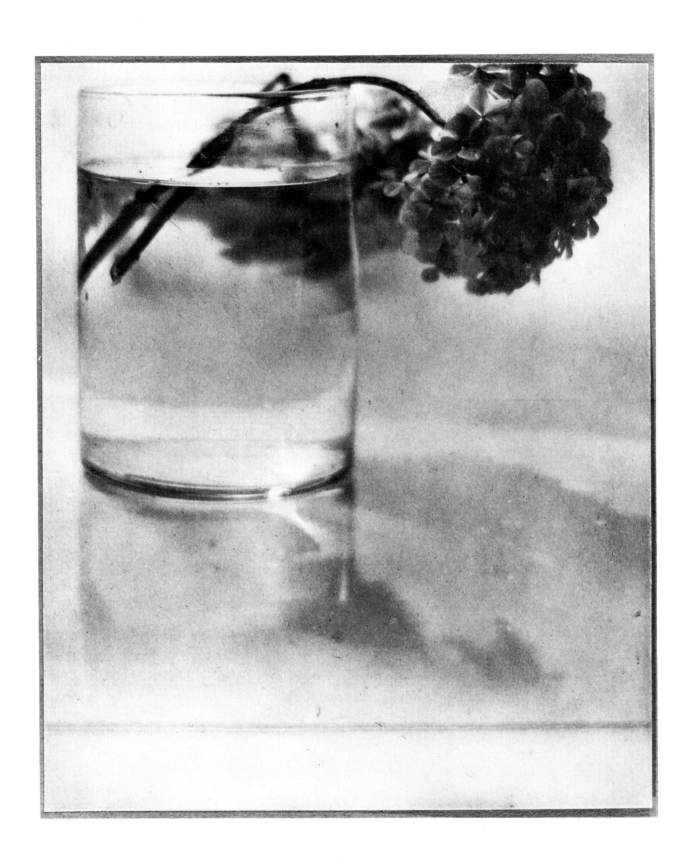

Adolf De Meyer: *Still Life*

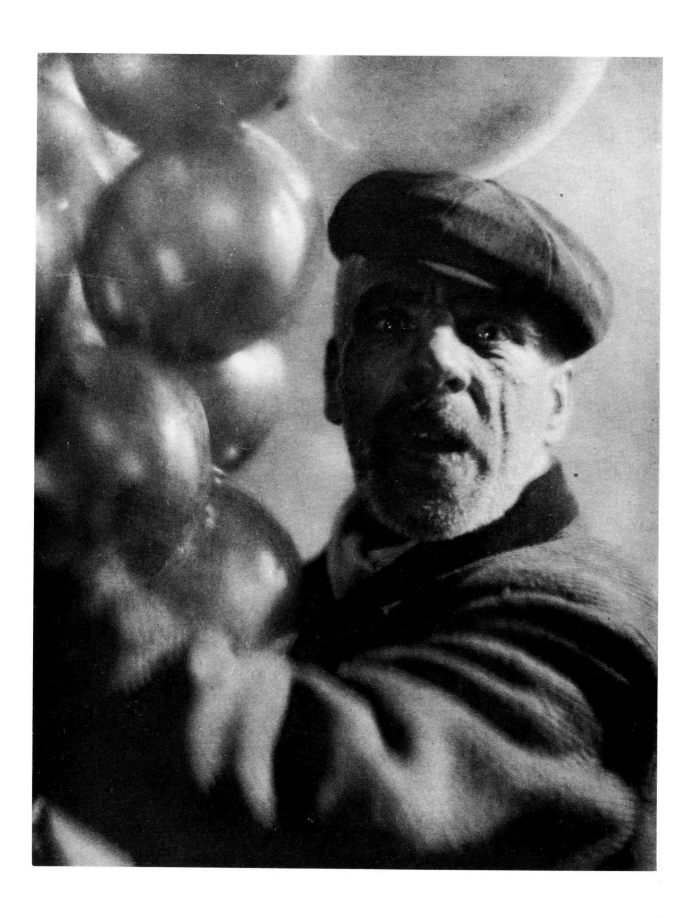

Adolf De Meyer: *The Balloon Man*

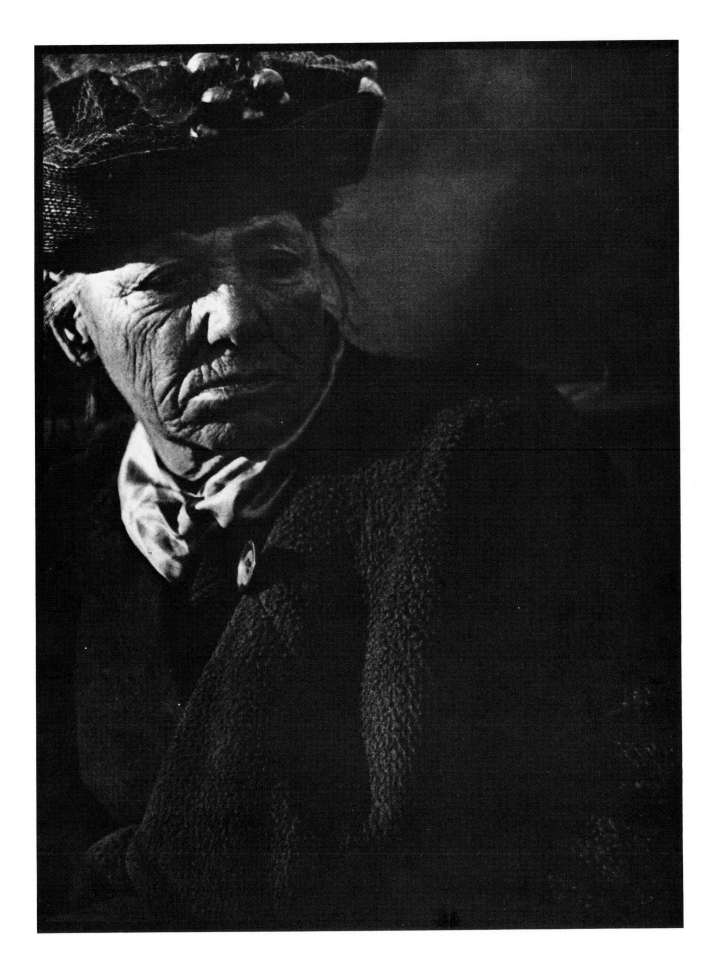

Paul Strand: *Photograph—New York*

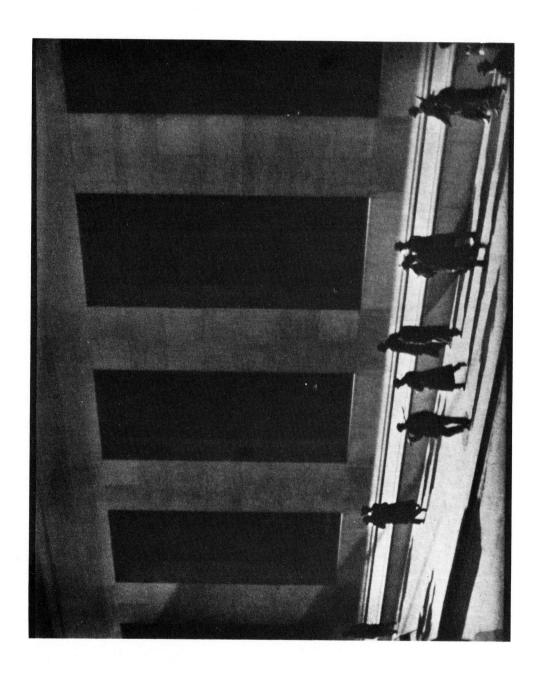

Paul Strand: *New York*

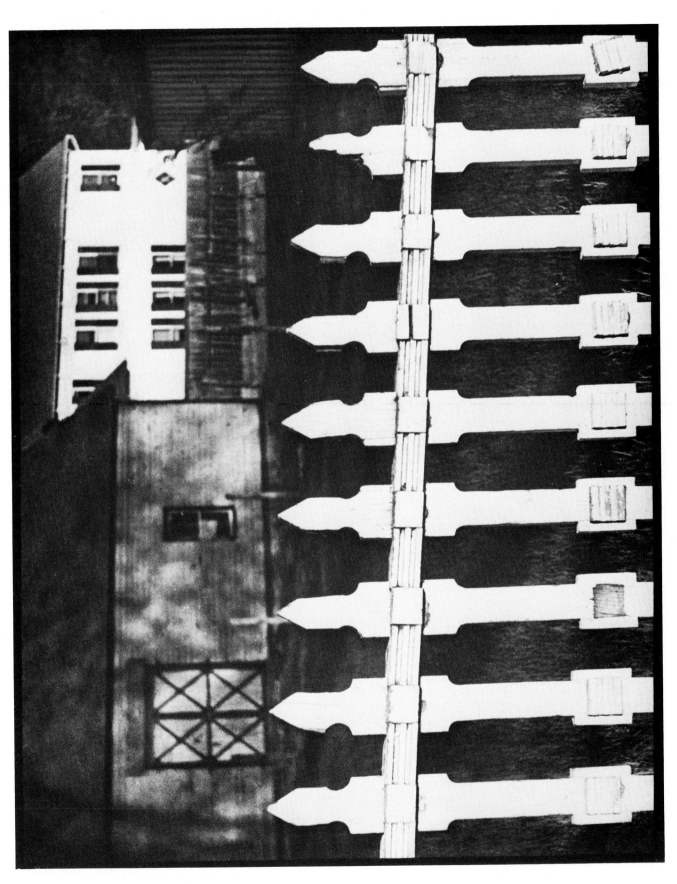

Paul Strand: *Photograph*

Paul Strand: *Photograph*

Paul Strand: *Photograph*

NOTES TO THE TEXT

1. Joseph Pennell, "Is Photography Among the Fine Arts?" *The Contemporary Review,* Vol. 72, 1897, p. 829.
2. Unpublished letter, Sept. 29, 1889, Stieglitz Archive, Collection of American Literature, Yale University Library.
3. Kathryn Staley, "Photography As A Fine Art," *Munsey's Magazine,* Vol. 14, 1896, p. 584.
4. George Davison, "The Photographic Salon," *American Amateur Photographer,* Vol. 5, Nov., 1893, pp. 495-498.
5. Charles H. Caffin, *Photography As A Fine Art.* New York, Doubleday, Page & Company, 1901, p. 39.
6. *Camera Notes,* Vol. 1, July, 1897, p. 3.
7. Henry G. Abbott, "The Chicago Photographic Salon," *Photo Era,* Vol. 4, May, 1900, p. 146.
8. Unpublished letter, April 18, 1900, Stieglitz Archive.
9. A word used by the editor of this publication, in place of "photograph."
10. "The Work of the Year," *Photograms of the Year.* 1900, p. 66.
11. Unpublished letter, July 31, 1900, Stieglitz Archive.
12. Joseph Keiley, "The Decline and Fall of the Philadelphia Salon," *Camera Notes,* Vol. 5, No. 4, April, 1901, p. 280.
13. Unpublished letter, Stieglitz Archive.
14. Unpublished letter, Stieglitz Archive.
15. Unpublished letter, Stieglitz Archive.
16. Dallet Fuguet, "Reviews of the Exhibition of Prints by Frank Eugene: By a Photographer," *Camera Notes,* Vol. 3, No. 4, April, 1900, p. 213.
17. Gertrude Käsebier, "Studies In Photography," *The Photographic Times,* Vol. 30, June, 1898, p. 270.
18. Unpublished letter, no date, Stieglitz Archive.
19. *Camera Work,* No. 12, Oct., 1905, p. 59.
20. *Camera Work,* No. 14, April, 1906, p. 48.
21. They completely overlooked the fact that Hill worked in collaboration with Robert Adamson.
22. Joseph Keiley, "The Photo-Secession Exhibition at the Pennsylvania Academy of Fine Arts — Its Place and Significance in the Progress of Pictorial Photography," *Camera Work,* No. 16, Oct., 1906, p. 51.
23. Unpublished letter, Collection of Mrs. Dorothy Norman, New York.
24. Interview with the author, May 12, 1960.
25. *New York Times,* Jan. 5, 1908, Part One, p. 9.
26. George F. Of ran a frame-making shop in New York. He made all the frames for the Photo-Secession exhibitions and for the work shown at "291."
27. Unpublished letter, no date, Stieglitz Archive.
28. "Unphotographic Paint — The Texture of Impressionism," *Camera Work,* No. 28, Oct., 1909, p. 23.
29. Charles Caffin, "Some Impressions from the International Photographic Exposition, Dresden," *Camera Work,* No. 28, Oct., 1909, p. 33.
30. Unpublished letter, Stieglitz Archive.
31. Christian Brinton, "American Art In Germany: The Value of Our Present Exhibition in Berlin and Munich," *The Craftsman,* Vol. 18, June, 1910, pp. 318-319.
32. Charles Caffin, "Irresponsibility in High Places," *Camera Work,* No. 26, April, 1909, p. 25.
33. Paul Haviland, "The Photo-Secession and Photography," *Camera Work,* No. 31, July, 1910, p. 42.
34. F. Austin Lidbury, "Some Impressions of the Buffalo Exhibition," *American Photography,* Vol. 4, Dec., 1910, p. 681.
35. Joseph Keiley, "What Is Beauty," *Camera Work,* No. 31, July, 1910, p. 67.
36. Unpublished letter, Dec. 22, 1911, Stieglitz Archive.
37. Unpublished letter, no date, Stieglitz Archive.
38. Unpublished letter, April 30, 1914, Stieglitz Archive.
39. Unpublished letter, April 7, 1913, Stieglitz Archive.

SELECTED BIBLIOGRAPHY

The following periodicals, and one annual, are the principal sources of material on the Photo-Secession and its background. They contain articles and reproductions which are too numerous to list here.

American Amateur Photographer, published by W. H. Burbank, F. C. Beach, W. G. Chase, Brunswick, Maine, 1889-1892; published by the Outing Co., Ltd., New York, 1893-1907.

Camera Notes, published by the Camera Club, New York, 1897-1903.

Camera Work, published by Alfred Stieglitz, New York, 1903-1917.

Photograms of the Year, published for the Photogram, Ltd., London, 1895 - to date.

The following are a selection of articles and books on the Photo-Secession, its principal members, and the general background.

Academy Notes (Journal of the Albright Art Gallery), Vol. 6, No. 1, Jan., 1911.

ALLAN, SIDNEY (Sadakichi Hartmann), "The Exhibition of the Photo-Secession," *The Photographic Times-Bulletin,* Vol. 36, March, 1904, pp. 97-105.

BICKNELL, GEORGE, "The New Art In Photography: work of Clarence H. White," *The Craftsman,* Vol. 9, Jan., 1906, pp. 495-510.

BLACK, ALEXANDER, "The Artist and the Camera," *The Century Magazine,* Vol. 64, Oct., 1902, pp. 813-822.

BRY, DORIS, "Alfred Stieglitz: Photographer." Introduction to catalogue of Stieglitz Exhibition, National Gallery of Art, Washington, D. C., March 15, to April 27, 1958.

CAFFIN, CHARLES H., "The New Photography," *Munsey's Magazine,* Vol. 27, Aug., 1902, pp. 729-737.

————, *Photography As A Fine Art.* New York, Doubleday, Page & Co., 1901.

————, "Progress In Photography, with special reference to the work of Eduard J. Steichen," *The Century Magazine,* Feb., 1908, Vol. 64, pp. 483-498.

EDGERTON, GILES, "The Lyric Quality in the Photo-Secession Art of George H. Seeley," *The Craftsman,* Vol. 13, Dec., 1907, pp. 298-303.

EMERSON, PETER HENRY. *Naturalistic Photography.* London, Sampson Low, Marston, Searle & Rivington, 1889.

FRANK, WALDO, AND LEWIS MUMFORD, DOROTHY NORMAN, PAUL ROSENFELD, HAROLD RUGG, EDS., *America and Alfred Stieglitz, a Collective Portrait.* Garden City, N. Y., Doubleday, Doran & Co., 1934.

HARTMANN, SADAKICHI (Sidney Allan), "Aesthetic Activity In Photography," *Brush and Pencil,* Vol. 14, April, 1904, pp. 24-40.

————, "The Photo-Secession, A New Pictorial Movement," *The Craftsman,* Vol. 6, April, 1904, pp. 30-37.

HOLME, CHARLES, ED., "Art In Photography," *The Studio,* Special Summer Number, 1905.

KÄSEBIER, GERTRUDE, "Studies In Photography," *The Photographic Times,* Vol. 30, June, 1898, pp. 269-272.

LIDBURY, F. A., "Some Impressions of the Buffalo Exhibition," *American Photography,* Vol. 4, Dec., 1910, pp. 676-681.

MACCOLL, W. D., "International Exhibition of Pictorial Photography at Buffalo," *The International Studio,* Vol. 43, March, 1911, sup. pp. 11-14.

MOORE, H. H., "The New Photography," *The Outlook,* Vol. 83, June 23, 1906, pp. 454-463.

NEWHALL, BEAUMONT. *The History of Photography.* New York, The Museum of of Modern Art, 1949.

NEWHALL, NANCY, "What Is Pictorialism," *Camera Craft,* Vol. 48, Nov., 1941, pp. 653-663.

NORMAN, DOROTHY, ED., "Alfred Stieglitz," *Aperture,* Vol. 8, No. 1, 1960.

————, ED., "From the Writings and Conversations of Alfred Stieglitz," *Twice A Year,* No. 1, Fall-Winter, 1938, pp. 77-110.

————, ED., "Special Stieglitz Section,' *Twice A Year,* Double Number, 8-9, Spring-Summer, 1942, Fall-Winter, 1942, pp. 105-178.

OLIVER, MAUDE I. G., "The Photo-Secession In America," *The International Studio,* Vol. 32, Sept., 1907, pp. 199-215.

ROBINSON, HENRY PEACH. *Pictorial Effect In Photography.* London, Piper & Carter, 1869.

SAVERY, JAMES C., "Photo-Secession," *Burr McIntosh Monthly,* Vol. 12, April, 1907, pp. 36-43.

SHAW, GEORGE BERNARD, "Alvin Langdon Coburn," *Wilson's Photographic Magazine,* Vol. 43, March, 1906, pp. 107-109.

STEICHEN, EDUARD, "The American School," *The Photogram,* Vol. 8, Jan., 1901, pp. 4-9.

————,"The Fighting Photo-Secession," *Vogue,* June 15, 1941, pp. 22, 74.

STIEGLITZ, ALFRED, "Modern Pictorial Photography," *The Century Magazine,* Vol. 64, Oct., 1902, pp. 822-826.

————, "The Photo-Secession," *The American Annual of Photography,* 1904, pp. 41-44.

————, "The Photo-Secession — Its Objects," *Camera Craft,* Vol. 7, Aug., 1903, pp. 81-83.

————, "Pictorial Photography," *Scribner's Magazine,* Vol. 26, Nov., 1899, pp. 528-537.

————, "A Plea for a Photographic Art Exhibition," *The American Annual of Photography and Photographic Times Almanac,* 1895, pp. 27-28.

————, "The Progress of Pictorial Photography in the United States," *The American Annual of Photography and Photographic Times Almanac,* 1899, pp. 158-159.

YELLOT, O. I., "The Outlook for 1903," *Photo-Era,* Vol. 10, Jan., 1903, pp. 25-26.

EXHIBITION SCHEDULE

Exhibitions held at "The Little Galleries of the Photo-Secession" (later called "291")

1905

November 24 - January 4	Exhibition of Member's Work

1906

January 10 - January 24	Exhibition of Work by French Photographers
February 5 - February 19	Photographs by Gertrude Käsebier and Clarence White
February 21 - March 7	British Exhibition No. I: Annan, Evans, Hill
March 9 - March 24	Photographs by Eduard Steichen
April 7 - April 28	German and Austrian Photographers
November 10 - December 30	Exhibition of Member's Work

1907

January 5 - January 24	Drawings by Pamela Coleman Smith
January 25 - February 12	Photographs by Baron A. De Meyer & George Seeley
February 19 - March 5	Photographs by Alice Boughton, William B. Dyer, C. Yarnall Abbott
March 11 - April 10	Photographs by Alvin Langdon Coburn
November 18 - December 30	Exhibition of Member's Work

1908

January 2 - January 21	Drawings by Auguste Rodin
February 7 - February 25	Photographs by George Seeley
February 26 - March 11	Etchings by Willi Geiger, Etchings by D. S. McLaughlan, Drawings by Pamela Coleman Smith
March 12 - April 2	Photographs by Eduard Steichen
April 6 - April 25	Drawings, lithographs, water colors, etchings by Henri Matisse
December 8 - December 30	Exhibition of Member's Work

1909

January 4 - January 16	Caricatures by Marius de Zayas, Autochromes by J. Nilsen Laurvik
January 18 - February 1	Photographs by Alvin Langdon Coburn
February 4 - February 22	Photographs in Color and Monochrome by Baron A. De Meyer
February 26 - March 10	Etchings, Dry-point, Bookplates by Allen Lewis

March 17 - March 27	Drawings by Pamela Coleman Smith
March 30 - April 17	Sketches in oil by Alfred Maurer, water colors by John Marin
April 21 - May 7	Photographs of Rodin's "Balzac," by Eduard Steichen
May 8 - May 18	Paintings by Marsden Hartley
May 18 - June 2	Exhibition of Japanese Prints from the F. W. Hunter Collection, New York
November 24 - December 17	Monotypes and drawings by Mr. Eugene Higgins
December 20 - January 14	Lithographs by Henri de Toulouse-Lautrec

1910

January 21 - February 5	Color photographs by Eduard Steichen
February 7 - February 19	Water colors, pastels, and etchings by John Marin
February 23 - March 8	Drawings and reproductions of paintings by Henri Matisse
March 9 - March 21	Younger American Painters
March 21 - April 18	Drawings and water colors by Rodin
April 26 - Indefinitely	Caricatures by Marius de Zayas
November 18 - December 8	Lithographs by Manet, Cézanne, Renoir, and Toulouse-Lautrec; drawings by Rodin; paintings and drawings by Henri Rousseau
December 10 - January 8	Drawings and etchings by Gordon Craig

1911

January 11 - January 31	Drawings and paintings by Max Weber
February 2 - February 22	Water colors by John Marin
March 1 - March 25	Water colors by Cézanne
March 28 - April 25	Drawings and water colors by Pablo Picasso
Exact date Unknown	Water colors by Gelett Burgess
December 18 - January 15	Photographs by Baron A. De Meyer

1912

January 18 - February 3	Paintings by Arthur B. Carles
February 7 - February 26	Paintings and drawings by Marsden Hartley
February 27 - March 12	Pastels by Arthur G. Dove
March 14 - April 6	Sculpture and drawings by Henri Matisse
April 11 - May 10	Exhibition of Children's Work
November 20 - December 12	Caricatures by Alfred J. Frueh
December 15 - January 14	Drawings and paintings by Abraham Walkowitz

1913

January 20 - February 15	Water colors by John Marin

February 24 - March 15	Photographs by Alfred Stieglitz
March 17 - April 5	Exhibition of New York studies by Francis Picabia
April 8 - May 20	Exhibition by Marius de Zayas
November 19 - January 3	Drawings, pastels and water colors by A. Walkowitz

1914

January 12 - February 14	Paintings by Marsden Hartley
February 18 - March 11	Second exhibition of children's work
March 12 - April 4	Sculpture by Constantine Brancusi
April 6 - May 6	Paintings and drawings by Frank Burty
November 3 - December 8	African sculpture
December 9 - January 11	Drawings and paintings by Picasso & Braque; Archaic Mexican pottery and carvings; Kalogramas

1915

January 12 - January 26	Paintings by Francis Picabia
January 27 - February 22	Paintings by Marion H. Beckett & Katherine N. Rhoades
February 23 - March 26	Oils, water colors by John Marin
March 27 - April 17	Third exhibition of children's work
November 10 - December 7	Drawings and paintings by Oscar Bluemner
December 8 - January 19	Sculpture and drawings by Elie Nadelman

1916

January 18 - February 12	Marin water colors
February 14 - March 12	Drawings and water colors by A. Walkowitz
March 13 - April 3	Photographs by Paul Strand
April 4 - May 22	Paintings by Marsden Hartley
May 23 - July 5	Drawings by Georgia O'Keeffe, water colors by C. Duncan, oils by René Lafferty
November 22 - December 20	Water colors and drawings by Georgia S. Engelhard, of New York, a child ten years old
December 17 - January 17	Water colors by A. Walkowitz

1917

January 22 - February 7	Marsden Hartley — recent work
February 14 - March 3	Water colors by John Marin
March 6 - March 17	Paintings, drawings, pastels by Gino Severini
March 20 - March 31	Paintings and sculpture by S. Macdonald-Wright
April 3 - May 14	Recent work by Georgia O'Keeffe

MEMBERS OF THE PHOTO-SECESSION

ADAMSON, PRESCOTT	Philadelphia	LADD, SARAH H.	Portland, Ore.
AGNEW, W. P.	New York	LAMB, LOUIS A.	Chicago
ALBRIGHT, CHARLOTTE C.	Buffalo, N. Y.	LANCE, H. W.	New York
ALEXANDER, J. W.	New York	LAURVIK, J. N.	New York
ASPINWALL, JOHN	Newburgh, N. Y.	LAWRENCE, C. A.	New York
BATES, A. C.	Cleveland, Ohio	LAWRENCE, FRED K.	Chicago
BOUGHTON, ALICE	New York	LAWRENCE, S. BRAINERD	New York
BOURKE, EDWARD L.	Chicago	LEESON, ADELAIDE C.	Douglas, Alaska
BOURSAULT, A. K.	New York	LEWIS, A. A.	New York
BOWLES, JOHN M.	New York	LOHMAN, HELEN	New York
BRIGMAN, ANNIE W.	Oakland, Cal.	MACDOWELL, C. H.	Chicago
BROWN, F. E.	Grand Rapids, Mich.	MARKS, F. E.	Camden, N. J.
BRUGUIERE, FRANCIS	San Francisco	MAURER, OSCAR	San Francisco
BUEHRMANN, ELIZABETH	Chicago	McCORMICK, L. M.	Asheville, N. C.
*BULLOCK, JOHN G.	Philadelphia	MOONEY, ARTHUR	New York
CAFFIN, CHARLES H.	New York	MULLINS, W. J.	Franklin, Pa.
CARKHUFF, NORMAN W.	Washington	PEABODY, CHARLES	Cambridge, Mass.
CARLIN, W. E.	New York	PEABODY, JEANETTE B.	Cambridge, Mass.
CARTER, S. R.	Toronto, Canada	POST, WM. B.	Fryeburg, Me.
COBURN, ALVIN L.	Boston	POTTS, OLIVE M.	Philadelphia
COBURN, MRS. F. E.	New York	PRATT, F. H.	Worcester, Mass.
CROWTHER, C. C.	Kobe, Japan	*REDFIELD, ROBERT S.	Philadelphia
DEVENS, MARY	Boston	REID, HARRY B.	New York
DIXON, S. D.	New York	RIVES, LANDON	Cobham, Va.
DRIVET, J. M.	New York	ROEPPER, C. W.	Philadelphia
DURYEA, CHARLES B.	New York	RUBINCAM, HARRY C.	Denver
DURYEA, HIRAM	New York	SCHRAM, L. B.	New York
*DYER, WM. B.	Chicago	*SCHUTZE, EVA WATSON	Chicago
ECKSTEIN, W. G.	New York	SEARS, SARAH C.	Boston
*EUGENE, FRANK	New York	SEELEY, GEORGE	Stockbridge, Mass.
ELLIOT, J. MITCHELL	Philadelphia	SLOANE, T. O'CONOR	Orange, N. J.
FRANKLIN, DR. MILTON	New York	SMITH, H. S.	Boston
FRENCH, HERBERT G.	Cincinnati	STANBERY, MRS. G. A.	Zanesville, Ohio
*FUGUET, DALLETT	New York	STANBERY, KATHERINE	Zanesville, Ohio
HAVILAND, GEORGE	New York	*STEICHEN, EDUARD J.	New York
HAVILAND, PAUL B.	New York	STEPHANY, L. F.	Pittsburgh
HEINSHEIMER, L. A.	New York	STERNER, ALBERT E.	New York
HESS, H. A.	Springfield, Ill.	*STIEGLITZ, ALFRED	New York
HODGINS, J. P.	Toronto, Canada	*STIRLING, EDMUND	Philadelphia
HOLST, L. J. R.	New York	STOKES, W. P.	Philadelphia
HOLZMAN, SAM S.	New York	*STRAUSS, JOHN F.	New York
HORNOR, S. S.	Concordville, Pa.	STRAUSS, KARL	New York
HUNTER, F. W.	New York	TYSON, ELIZABETH R.	Boston
JAMES, W. F.	Chicago	VAUX, G. B.	Philadelphia
JOHNSTON, FRANCES B.	Washington	VAUX, MARY	Philadelphia
JONES, WALTER G.	New York	WEBBER, S. S.	Trenton, N. J.
*KÄSEBIER, GERTRUDE	New York	*WHITE, CLARENCE	Newark, Ohio
KECK, EDWARD W.	Rochester, N. Y.	WHITE, LILY E.	Portland, Ore.
*KEILEY, JOSEPH T.	New York	WIGGINS, MYRA	Salem, Ore.
KELLOGG, SPENCER, JR.	Buffalo, N. Y.	WILDE, A. N.	Philadelphia
KERFOOT, J. B.	New York	WILLARD, S. L.	Chicago
KERNOCHAN, MARSHALL P.	New York	WILMERDING, W. E.	New York
KIMBELL, R.	New York		

*Denotes a founding member